More praise for
Emerging from the Flames

Eleanor is "not dead yet," and we should all be grateful. From her lofty perch of 80 years, and her youthful frolicking among the undergrowth of a deconstructed world, she graces us with words that remember and reveal. In poetry and prose, Eleanor names our profound universal experience of the 2020 pandemic through focused attention on the local and the personal. Yet she transcends both, to expose the wild and vulnerable spiritual longings and frustrations in each of us. Exploring fear, stillness, silence, liturgy, family, resilience, regret, hope, the unexpected, and indeed death itself, through a non-linear, non-binary spirituality, *Emerging from the Flames* allows the divine to break free and startle us into life.
—Rev. Dr. Charisa Hunter-Crump, Senior Minister, Cairn Christian Church (Disciples of Christ)

The story of our lives through the nightmare of COVID-19, the police killing of George Floyd and so many other Black victims, the massacre at the grocery store I shopped at for 40 years, the storming of the Capital, and the last year of Trump's presidency, as told in prose and poetry by Eleanor A. Hubbard, is softened, uplifted, transformed into hope, by the exquisite art of Pamela McKinnie. *Emerging From the Flames* is a poignant testament to the indomitable human spirit. I was especially touched by Eleanor's poem, "Fall," and I melted into Pam's "Healing Mother Earth," both reminding me that despite the intensity of our drama, we are part of a grand Adventure, in which All is Well
—Linda Kreger Silverman, Ph.D.
 Founder, Institute for the Study of Advanced Development/Gifted Development Center.

When COVID sparked quarantines, school closures, and business shutdowns, masks and social distancing became the reality of my life. I thought I should take up journaling or art to capture my experience of this once in a lifetime event for myself and future generations. Weeks turned into months and I grew weary. Writing stopped pretty quickly; art never even began. It turns out Pamela McKinnie and Eleanor A. Hubbard did what I did not do for myself. Thank you. Whatever your loss, fear, awakening, despair, hope, or joy since COVID entered our lives, it's likely you will find it on these pages. Dive into the words and the images. This beautiful volume provides a backdrop for personal reflection and, as a chronicle of resiliency, determination and hope, lifts the human spirit.
—Barbara Mitchell Hutton, M.A. Educator and Consultant to the Gifted

EMERGING
FROM THE FLAMES

*Poetic & Artistic Musings on Life
Spirituality, and the Coronavirus*

**Poetry and Prose by Eleanor A. Hubbard
Art by Pamela McKinnie**

Photo Credit Barbara Mitchell Hutton

Acknowledgments

Emerging from the Flames is dedicated to all those who survived and even thrived during COVID. We could not have done so without the health care workers, first responders, educators, and workers in critical industries who sacrificed to keep us safe as we slowly return to our "new-normal." Even though the year 2020 is now history, COVID is not, so we continue to work together with the same resilience and faith that got us through that year. And to all those world-wide who lost their lives due to COVID, to all those loved ones who miss each person daily, and to all of us who mourn our collective loss, we humbly ask you to receive this collection of musings and art as our gift.

Pamela McKinnie and Eleanor A. Hubbard

As in art, poetry, music, the best theology is worked out in pain.— Rev. Steve Chalke

Published by
Bolder Press
Boulder, CO

Cover Design:
Pamela McKinnie
www.PamelaMcKinnieArt.com
www.ConceptsUnlimitedInc.com

ISBN: 979-8-47792-501-8 (pbk)

Table of Contents

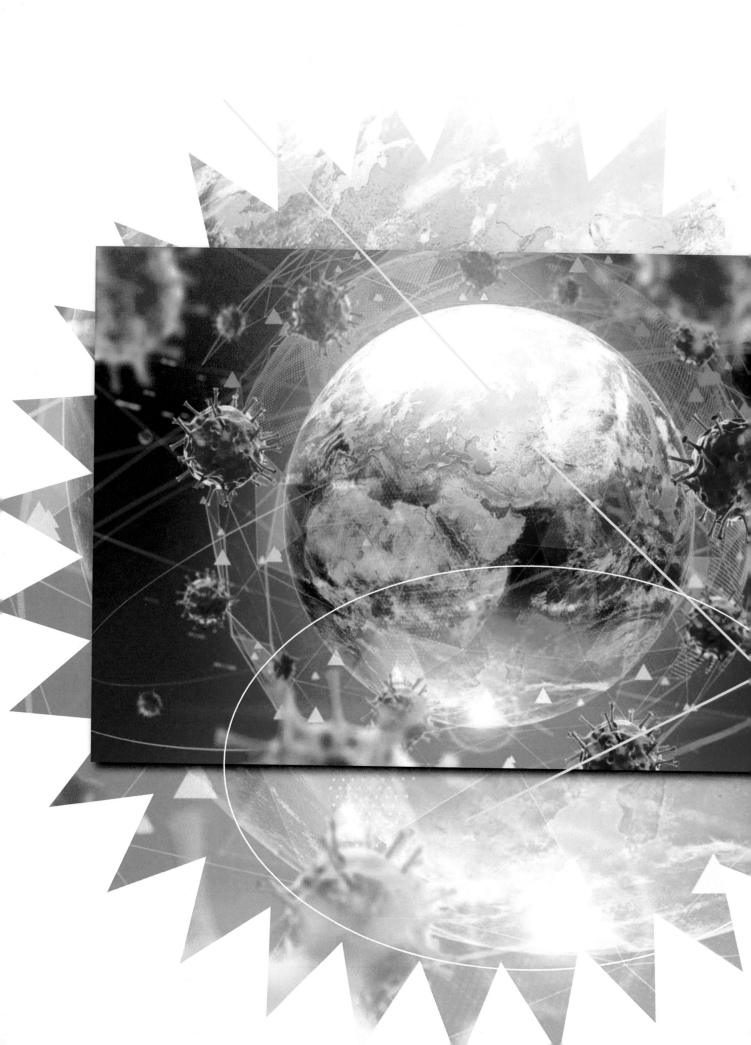

Covid−19 (aka the novel Coronavirus)
A poetic rendering of Psalms 8:4-6

Trust God who dances in the flames
Origen of Alexandra, 184-253 AD

Stare into the face of fire
Red, orange, blue, yellow, white, then black
Fire, the color of fear, the color of hope
Dance, play, flirt, consume
Enchantress, destroyer.

Why bother with us? Are we but virus receptacles?

COVID-19, Coronavirus
Red, orange, blue, yellow, white, then black
Danse Macabre, the dance of death
destroy, separate, sing, devour
Sorceress, warrior.

Do you even take a second look at us? Are we but ashes fit for the dump?

Sun halo in the sky, green flash at sea
Aurora borealis, the northern lights
Swirl pink, green, yellow, blue, violet
Sometimes orange and white.
Fire in the stratosphere.

I have seen you in the sky, where are you on earth?

assailant, marauder
procreating, multiplying
unseen by the naked eye
take your retribution
on the weak, elderly, susceptible.

Are we lower than the Angels? Are we higher than the animals?

While I sit safely in my home,
nurses, doctors, cleaning staff
hear coughs, watch labored
breathing, see temperatures flair
go home exhausted.

Are you there dancing in the flames?

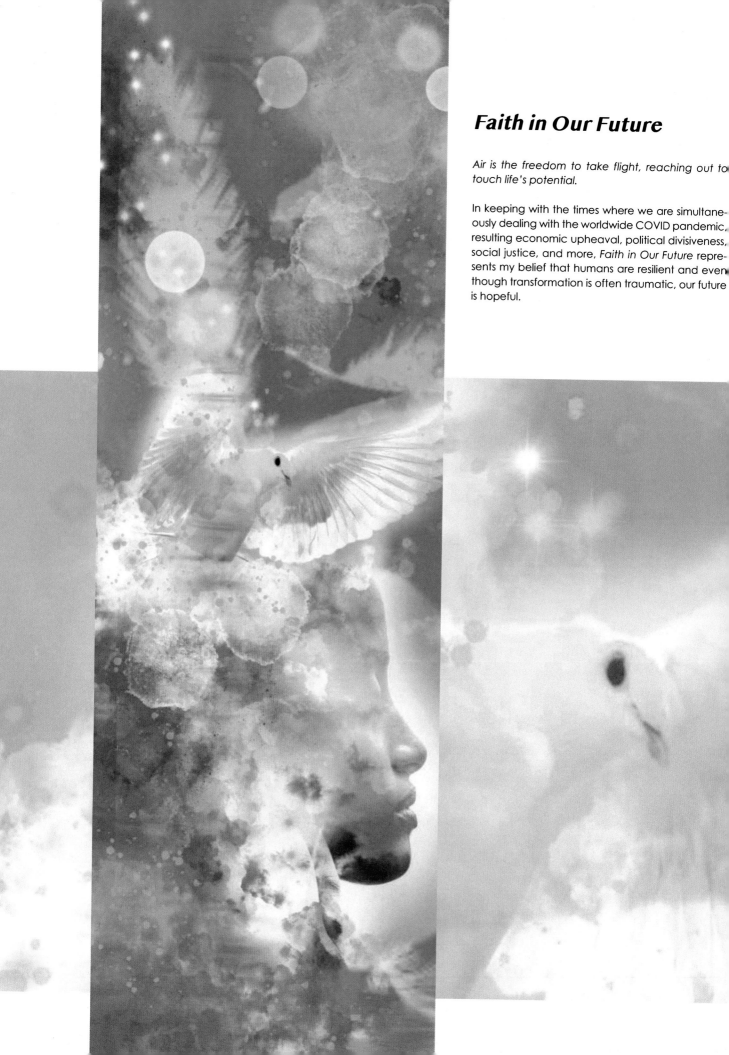

Faith in Our Future

Air is the freedom to take flight, reaching out to touch life's potential.

In keeping with the times where we are simultaneously dealing with the worldwide COVID pandemic, resulting economic upheaval, political divisiveness, social justice, and more, *Faith in Our Future* represents my belief that humans are resilient and even though transformation is often traumatic, our future is hopeful.

Initial Thoughts

It was the best of times, it was the worst of times, it was the age of wisdom, it was the age of foolishness, it was the epoch of belief, it was the epoch of incredulity, it was the season of Light, it was the season of Darkness, it was the spring of hope, it was the winter of despair, we had everything before us, we had nothing before us, we were all going direct to Heaven, we were all going direct the other way – in short, the period was so far like the present period, that some of its noisiest authorities insisted on its being received, for good or for evil, in the superlative degree of comparison only.

—*Charles Dickens (1859). A Tale of Two Cities.*

Initial thoughts by Eleanor

Although in January, I didn't know this winter would be endless, the phrase, "It was the best of times, it was the worst of times," reverberated in my head, and soon became my mantra. All I knew was that the phrase was from *A Tale of Two Cities*, by Charles Dickens. Strangely, I had never read this novel, or anything by Dickens for that matter, so I decided now was the time. As I read the book, the opening paragraph and then the whole book seemed prescient. Cracks of race, gender, class and poverty were revealed in 1859, when Dickens wrote the book, and again in 2020 as we in the United States were changed by the Coronavirus.

Each passing month increasingly revealed our lack of historical insight and compassion. Poor leadership compounded the problem. How could this be happening? By March, it became clear that 2020 would be a year to remember: 9/11 (the bombing of the Twin Towers in NYC and the Pentagon in Washington DC); 12/7 (Pearl Harbor Day), 6/6 (D-day) were dates that loom large in our memories, and now 1/6 (domestic terrorist attack on the Capitol). It all seemed surreal and too real.

I decided to document my personal journey through the endless winter into the spring, summer, fall and back to the winter against the backdrop of Coronavirus. I wanted to understand the personal, political and social toll it was taking on me and my family as well as on my community, state, and nation. I wanted to discover for myself whether it was possible to emerge from the flames of Coronavirus. Instead of whining and moaning, which was my first inclination, I wrote poetry and prose. I could not imagine many times this past year that we would indeed emerge from the flames.

I offer this as my contribution to the narratives of 2020.

Initial thoughts by Pamela

Eleanor and I have been colleagues and close friends for more than 30 years. During that time we have shared the many ups and downs of our personal, professional and political lives. In February 2020, in the midst of what seemed like an endless night of COVID dreaming, I awoke with the overpowering thought, "Eleanor and I should write a book together about 2020 and the Coronavirus!" I knew that Eleanor had written and published some poetry. I had created and shown some COVID art. We had pieces of what could become a book, but I had no idea about what form a collaborative book on 2020 might take.

When I summoned the courage to share my idea with Eleanor, I discovered that not only had she written multiple poems, she was recording her 2020 experience. We already had the beginning of a 2020 odyssey in poetry, prose, and art. At that point, *Emerging from the Flames: Poetic & Artistic Musings on Life, Spirituality, and the Coronavirus* was born.

For 20 years I have designed, illustrated, and published books for multiple indie authors. I never wanted to "write" my own book. However, as Eleanor shared her month-by-month musings combined with her insightful poetry, I envisioned how my art, created as a visual and emotional response to the impact of the pandemic, could easily fit with Eleanor's prose and poetry.

I have been drawing and painting for as long as I can remember. As an only child, I would save my 50¢ a week allowance until I could buy a paint-by-number kit or some other art project to feed my creative spirit. I moved from hand-drawn paper dolls and collages of garden flowers to oil painting, watercolor, traditional Chinese ink drawing, acrylics, collaging, sculpting, and all forms of mixed media.

I have always been an intuitive artist. I love to combine various art modalities, which sometimes leads to happy surprises and new ways of seeing life. My passion is to approach my art as a small child. I begin with a blank "canvas" and randomly brush, dab, drip, spray, and scrape paints, inks and other materials with no particular form in mind. After a few days of exploring the initial abstract, I discover the seed of an image that I liberate from the background. Multiple layers enhance the emerging image, which takes on a life of its own. Often something "other" than the visible appears, which to me is a testimony to the underlying connectedness of life.

This book contains my visual response to Eleanor's 2020 narrative combined with my own emotional and intuitive acknowledgment of the impact of the isolation, fear, death, and political upheaval of 2020 plus the moments of joy, peace, and faith in my fellow travelers that gave me hope that we would emerge from the flames into a brighter future.

LISTEN

For Now is the Time to Learn

January/February 2020

it was the best of times

I was born November 2, 1939 and in 2019. I celebrated my 80th birthday with an "I'm not Dead Yet" party. The theme, taken from Monty Python and the Holy Grail, was a celebration of my 80 years with laughter, food, and fun. On New Year's Eve, December 31st, a new novel virus was confirmed to be in China, but we heard nothing of this, so I made no connections to Epiphany, the first season of the Christian calendar. Epiphany celebrates the guests that attended Jesus' birth: shepherds, angels, and several distinguished foreigners, the Magi. My personal epiphany happened later as the new virus began to affect my family, my friends and me. Except for those trained in pandemics, no one foresaw what was in store for us in 2020.

January 19th the first Coronavirus case was identified in Washington State, and on January 22nd, Trump announced, "We have [coronavirus] totally under control. It's one person coming in from China...It's going to be just fine." (CNBC interview)

This became the administration's theme throughout January. "It's not here, won't be here, and we're all fine." They were definitely turning a blind eye to the coming disaster; I was reminded of the three monkeys, hear no evil, see no evil, speak no evil. By the end of January, the World Health Organization (WHO) declared a global health emergency, and the White House formed a Coronavirus response task force and banned travel from China on the 31st. On the cusp of February, we still lived as though it were the best of times.

I didn't know it at the time, but February was marked by many lasts: the last time for many months I would get my hair cut, get a manicure/pedicure and a massage, go to the movies and the theater, go out to eat, volunteer at the jail, or go to church. Those were my "normal" activities, which were

soon to disappear. During February, the number of coronavirus cases in the US went from 5 to 24, and on the 29th, the first death in the U.S. caused by the Coronavirus. The virus was tiptoeing closer to home.

From the administration, the theme for February turned from not a problem to a miracle will happen. On February 14, Trump said, "There's a theory that, in April, when it gets warm — that has been able to kill the virus." (speech to National Border Patrol Council) and on February 27th, "It's going to disappear. One day — it's like a miracle — it will disappear." (White House meeting with African American leaders)

Many experts did not agree. On February 11, WHO gave Coronavirus a name, COVID-19, and reported 60,000 cases globally with 1200 deaths. In the U.S., the stock market was in free fall, losing more than 1000 points on February 24th. MSNBC and CNN began 24-hour updates, while the Fox network was still echoing Trump's predictions.

I remember February for two reasons: a good friend's memorial service and a trip to Albuquerque. On Saturday, February 8th, Roger Hudiburg's memorial service was held at Cairn Christian Church. Music, lunch, hugs: no worries of COVID-19. Roger had suffered from Alzheimer's for over 5 years, and in December his wife, my dear friend Peggie, had him institutionalized. Shortly thereafter she was admitted to the hospital, where she bounded back and forth between rehabilitation centers for three months.

Roger's memorial service was delayed for a month, so that far-flung family and friends could come, and Peggie could be there. He was a teacher and a bluegrass musician, and the church was full of people with his music permeating the storytelling by his family and friends. One week later, Peggie was moved to an assisted living facility, where she died on February 16th.

Peggie was a woman who embodied hospitality. Her home was decorated by original Native American art, and she loved to entertain there. She welcomed everyone, served delicious self-prepared food, set a beautiful table, and enabled deep conversation. I was not surprised that she didn't want to live in a world without Roger, but I found it difficult to let her go. Now it feels like a metaphor. Things were falling apart, and I was unable to keep the pieces together.

On February 22nd, my husband Dennis and I flew to Albuquerque to spend the weekend with Wally and Val Ford. Three times in the previous three months, we had planned the trip, and then flu and colds by one or another prevented our going. We were finally all well, so we spent the weekend together watching movies, eating Thai food at a local restaurant, and having quiet conversation and long walks. We talked about the virus, but it still did not change our behavior.

Turning eighty was reflectively exciting. More time to think and play. More time to reflect on the meaning of life and my life. More time to worry about how life would be for my children and grandchildren. More time to grieve my losses.

I grew into eighty and felt comfortable in honoring what was and what would be. I was deeply grateful for my life lived. I was alone yet with family and friends. I was happy.

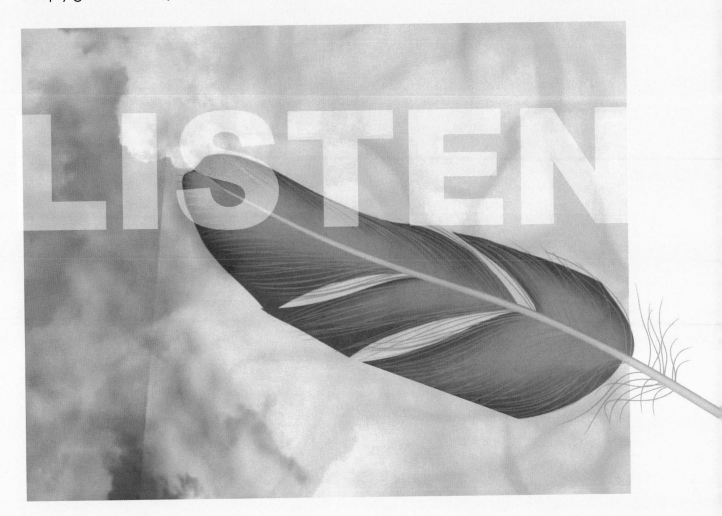

January 2020

Ring in the new year, twenty twenty
modern, postmodern, post-post-modern,
present-day, futuristic year.
No moderation this year
opposites ping-pong, attraction, repulsion.
War or peace, hate and love
hope or despair, laughter and tears
become one, comingle.

Open hearts smashed
optimism, honesty dismantled
exposed minds shattered,
curiosity, criticism deconstructed,
soul-destroying times.
Pessimism, irony, sarcasm
Control lust, doubt, disgust.
Hope bandaged and bleeding.

Complete the circle of life
seen too much at eighty
lived it, felt it, an extinguished fire.
The new feels old, tired, tried,
the same old shit.
Broken, battered, dismissed,
my eye on the prize,
so be it, amen.

Yet, I'm not dead yet!
Participate in the sadness
Enjoy the aliveness
Resist, repel, persist
anticipate, foresee, prophesy,
endings are beginnings
beginnings are endings
enjoy the view.

Seared by Silence

We criss cross without connection,
reinforce our own perceptions,
vilify the other's motives.
We are seared by silence.

We mirror each other's tones.
Confident. Caustic. Condemning.
We shout over meaningless chasms.
Disturbed. Seared by silence.

The distance deepens between us
in each other's presence or not.
Harsh words cut off communication.
We are scorched, seared by silence.

There is only now
and now is torture.

My unsafe vulnerable heart,
my unstable defenseless soul
long to lay down this weighty armament.

I crave protection, immunity from pain.

My well-worn, protective armor
ill-suited for this battle,
I unleash my hackneyed weapons.
Words gash deeper than whips.

Some say, fight back, use deadly
 ammunition.
You know where to aim it.
Others say accept the distance.
This is your reality! This too I fight.

Nothing calms my panic, nor eases my
 pain.
While lacerations fade, cauterized by fire,
a deep heart cramp explodes.
All becomes silence.

Silence sears. Silence shrivels
ghastly pain to a livable dullness.

O, Compassion

Where are you, Compassion?
Fury shrieks.
Safety for a few,
our walls rebuff the other.
Sealed within,
empathy congeals, stiffens.

Where are you, Compassion?
Frenzy screams.
Is your soul lost,
overcome by the din?
Engulfed by the cacophony,
buried by the hubbub?

Where are you, Compassion?
Turmoil squeals?
Is your broken heart, bled dry,
wounded, disabled,
damaged, humiliated,
still patiently waiting?

Where are you, Compassion?
Lethargy sighs.
Stillness. Silence.
Calmness. Quiet.
Patience. Peace.
Serenity.

Where are you, Compassion?
Passion whispers.
Call me by my name,
in quiet times.
I echo an ecstatic song,
I leap for joy.

Contrasts

A new decade, a new year,
a millennium becomes an adult.
A wobbly world moves unsteadily,
absent equilibrium.
Incongruity of light and dark collide.

At eighty, I wobble too,
inebriated with insanity. I feel
dizzy, giddy, weak at the knees.
Then excitement, vigor, animation,
a cacophony of contrasts.

Avoid excesses, I was taught, be moderation,
see the world in black and white.
Abstain from intemperance.
Restrain flamboyance.
Find sense in the nonsensical.

Hold on to binaries,
a time for this, for that.
Light, shadow. Blackness, radiance.
Preservation, transformation.
Instability, balance.

I seem strangely out of tune.
Balance war, peace: absurd!
Contrast hate, love: ludicrous!
Chiaroscuro, contrasts, balance,
make beautiful pictures, a difficult life.

Contemplate the contrasts.
Experience equanimity.
Live the absurd.

An unprotected mind, a ready heart,
a ridiculously open body.

Complexity, diversity, simplicity.
Emotion, sensations, soft-hearted.
Alleviate, restore, reconstruct.
Awkwardly smash binaries.
Humbly live inside the contrasts.

Published in Arlene S. Bice's *What it is to be a woman: an anthology.* PurpleStone Press, 2020.

Letting Things Go

Heirloom linens interesting collectibles
 a list of to-dos,
hateful feelings messy relationships
 a handmade cabinet,
artful vocabulary short-term memory
 a formidable voice,
friends passing changing identity
 a sense of decency,
fine-motor skills viable joints aspirations
 a drive to consume,
hopes longings obligations
 a predictable future,
vigor grip strength a long-lived-in home
 appropriateness,
impatience anxiety concerns cravings
 an elevated ego.

Anticipation, equanimity, confidence, intimacy,
 A broken hallelujah.

The God Search

Where can I find you, god?

In a man-boy
who studies puzzle pieces,
sleuths patterns.

In an infant
locked in baby detention,
screaming for her mother.

Who are you, god?

A delightful girl
who shinnies up climbing wall,
joyfully one with grips.

A family
inhabiting the roadside,
sign begging for food.

When will I find you, god?

With my friend
brewing mint tea,
so we can share our lives over a cookie.

With the outcast,
thrown out, sent away
outraged grief.

How will I find you, god?

With giraffes
munching on leaves,
oblivious to the crowd.

With the unexpected fox,
half-starved, searching
for food in suburbia.

What are you, god?
Paranoia, connection.
Dance, psychosis.
Obsession, song.
Life, death.

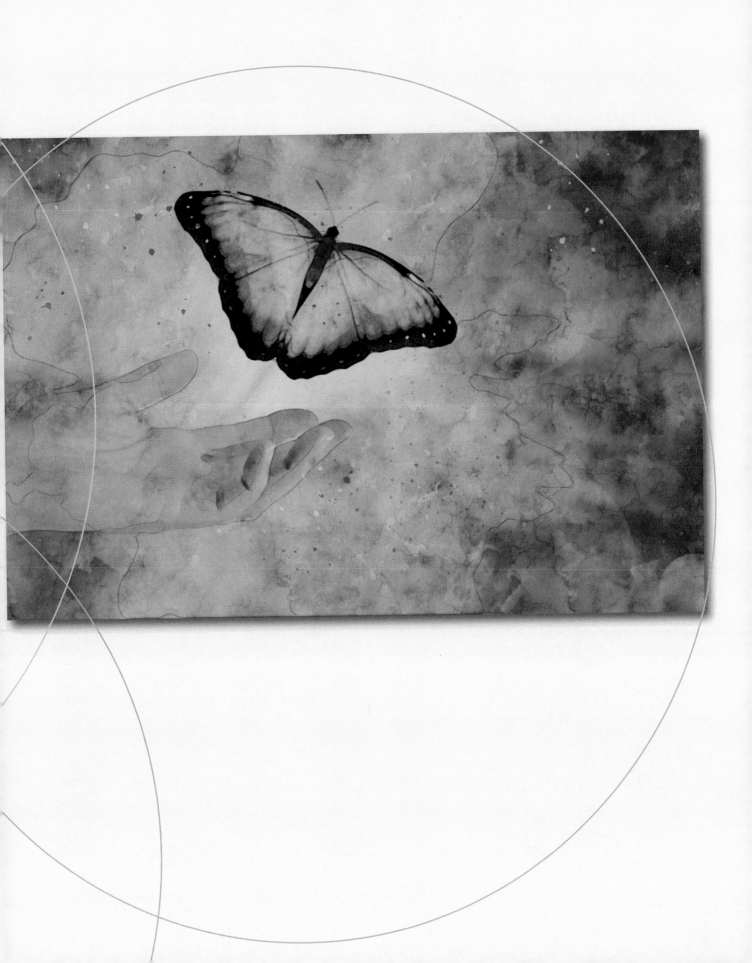

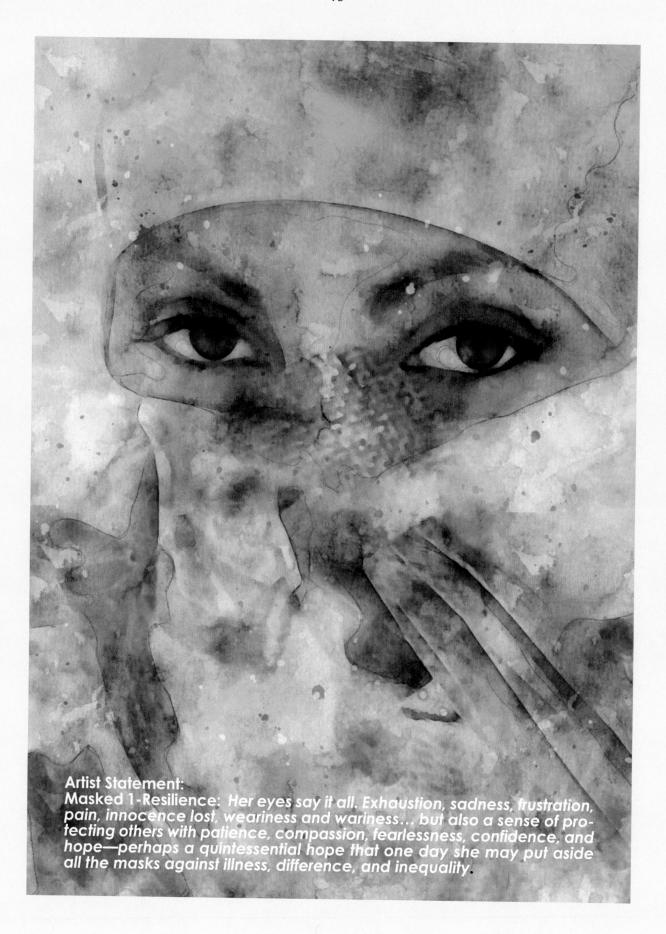

Artist Statement:
Masked 1-Resilience: *Her eyes say it all. Exhaustion, sadness, frustration, pain, innocence lost, weariness and wariness... but also a sense of protecting others with patience, compassion, fearlessness, confidence, and hope—perhaps a quintessential hope that one day she may put aside all the masks against illness, difference, and inequality.*

March 2020
it was the worst of times

*M*arch is always one of my favorite months because of several family birthdays and the beginning of the Christian celebration of Lent and Holy Week. On March 7th, our second daughter Natasha turned 48; on March 12th, Brian, the father of our grandchildren, turned 52; and on March 16th, my brother Lloyd turned 84. On St. Patrick's Day, March 17th, my mother Beatrice, if she were still alive, would have turned 117. This year though, March marked the time when the best of times became the worst of times.

We celebrated Natasha's birthday with breakfast at the Walnut Café and anticipated going to see *Mean Girls*, at the Denver Center for the Performing Arts later in the month. That was not to be. Still, that morning, our conversations about the Coronavirus were focused on how bad COVID-19 might be and whether our lives would be affected. Dennis and I had never thought about ourselves as a vulnerable population, and now we began to reflect on how this might impact us more than the younger people we know. Everything changed nine days later on my brother's birthday.

Three and a half years older than I, my brother Lloyd had Parkinson's Disease and lived in a nursing home in Iowa, not far from where he farmed the family farm. Before I called him on his birthday, Lori, his daughter, told me that Oakview Nursing Home, where he lived, was quarantined and that he was not allowed out of his room, even for meals. This brought COVID-19 home, in a new way.

On my brother's 84th birthday, after the phone call to Lloyd, Dennis and I decided to self-isolate, and literally overnight our lives changed. We went to the grocery store weekly during "old geezer hours" vs. whenever the need arose. We learned new words; zoom, face masks, and social distancing. Our social interactions now were confined to zoom, a technology that

allows multiple people to see each other virtually on the same computer screen or phone. We began to wear face masks, first those we made ourselves from material laying around the house and then later ones made by a neighbor and wore them whenever we were away from home. To social distance meant to avoid groups and when together to be at least six ft. apart.

For 80-year-olds, Dennis and I were healthy, active, but we began to follow all of the stay-at-home orders. Family, friends, and neighbors watched out for us and asked what we needed. Our church family came into our home through zoom. We stayed in touch with people via phone and emails. We had outside neighborly chats with positive social distancing. The news reminded us daily of those people who were impacted more by Coronavirus than we, and we recognized how privileged we were.

Ash Wednesday was February 26th and marked the first day of Lent which culminated in Holy Week. Lent is traditionally 40 days, a significant number throughout the Hebrew Bible. Most significantly for the Christian though, Jesus wandered in the wilderness for 40 days and was tempted by Satan three times: to satisfy his hunger, to be saved if he threw himself over the cliff, and to achieve great wealth and power. In 2020, Ash Wednesday foreshadowed the darkness which would consume March.

In order to prepare for Holy Week, traditionally Christians have used the 40 days of Lent for repentance, fasting, prayer, and reflection: how we are tempted by overindulgence, easy salvation, and materialism. Ash Wednesday's purpose is to remind Christians that we are born to die, or as the Hebrew Bible, King James version reminds us, "...for dust thou art, and unto dust shalt thou return." (Genesis 3:19b) The Message states it more plainly, "...you started out as dirt, you'll end up dirt." This phrase is said by the pastor or priest while marking the sign of the cross on a participant's forehead, always a memorable moment for me. That significant night, there were still only intimations of what was to come by the end of March due to Coronavirus.

At the beginning of March, there were 15 confirmed cases of COVID-19 in the U.S., but almost 3000 deaths worldwide, and a new word entered our vocabulary, pandemic. An epidemic is when an infectious disease is widespread in a particular community at a particular time; a pandemic is when that disease spreads across the globe. On March 11, WHO declared the global outbreak of Coronavirus a pandemic.

Throughout March, the number of cases skyrocketed in the U.S. and in Colorado. The first reported case in my state was confirmed on March 5th, and by the 15th one person had died of the disease. By the end of the month, in the U.S., there were 22,635 cases and 2,500 deaths, and the Colorado numbers were no less scary: 2627 cases, 51 deaths. Like many other governors, Jared Polis of Colorado announced a stay-at-home order with only essential service businesses open under strict guidelines. Most people did not object because most believed that the quarantine would only last a few weeks, yet one year later, Colorado and most other states would still be in quarantine.

Isn't March supposed come in like a lion and go out like a lamb? Not this year. What a difference a month makes. On March 1, we were aware of but largely untouched by the Coronavirus, and by the end of the month, our lives had changed.

The worst is still to come, they say. Evidently the lion ate the lamb in March 2020.

It Was the Best of Times,
It Was the Worst of Times, 2020
With a nod to Charles Dickens

orange sunrises explode
amorphous autumn days

contemplate
movies streamed
amid soft flannel sheets

reflect on
fire red sunsets
snow smothers flames.

Was it the best of times or the worst of times?

ponder
golden aspen leaves die
a brown lonely death

perceive
president, wildfires rage
words, ash settle thoughtlessly

consider
moments of despair
dashed dreams, smashed hopes.

Was it the worst of times or the best of times?

isolation sows
interminable days, unceasing nights
quarantine sprouts
complexity, negates simplicity
segregation incubates
injury, injustice
proximity hatches
closeness, presence
kinship gleans.

Pandemic Reflections

We are but husk
tossed by winds
easily swayed.

We are chaos
confusion, disorder
adrenaline junkies.

We are masquerades
hiding in illusion
pretend humans.

Stand on calmness
find your center
be still.

Curb your busy body
minimize distress
be tranquil.

Block out all noise
quiet your inner voices
be wordless.

Release your spirit
listen to her
be silence.

When There Are No Words

Overcome by chaos
Consumed by dread
Lost in fear
Silenced by noise

No words.

Overcome by calm
Consumed by zeal
Lost in trust
Silenced by awe

No words.

New York City and Coronavirus
An Interlude

Dennis and I love New York City, visiting there more than a dozen times. Mostly we went to enjoy Broadway, and we would often go for three days and attend five plays, seeing such classics as Book of Mormon, Trip to Bountiful, and Lion King. We even saw the Blue Man Group, before they were famous. We had the pleasure of seeing notable actors, such as Judi Dench, James Earl Jones, Nathan Lane, Bernadette Peters, Elaine Stritch, Marlo Thomas, and Cicely Tyson share their craft. We loved every minute of the time we spent in NYC.

Even though Broadway was our main purpose for going to New York, we also enjoyed many other delights of the city.

We walked neighborhoods throughout the city from Battery Park in the south end of Manhattan island to Harlem in the north. We've been to most of the boroughs, busing through the sprawling neighborhoods. We enjoyed exploring the global ethnic neighborhoods throughout the city, listening to the languages of the world, and tasting many foods for the first time. Rarely were we scared, almost always treated with respect and dignity, and felt that we belonged.

We usually stayed near Times Square, 42nd and Broadway, so we could walk to plays in the evening and to Central Park, which is less than a mile away. We wan-

dered around the Park, 840 acres, one and a third square miles, and worth at least 40 trillion dollars. It is where Jackie Kennedy jogged, where John Lennon's Strawberry Fields memorial is located, and where the Museum of Modern Art and Central Park Zoo reside. At the north end of the Park is Harlem where we loved to eat and mingle. We also sailed on the ferry to Staten Island, which circumnavigates the Statue of Liberty and continues on to Ellis Island, where we marveled at the stories of European immigrants.

Mid-September 2001, we had tickets to see Spamalot on Broadway. I was so excited as it was a musical made from the Monty Python and the Holy Grail movie, which I loved, and all our family was going to be there. Then 9/11 happened. New York City was devastated by two planes flying into the World Trade Center in Lower Manhattan.

Everyone remembers where they were on 9/11. I was walking toward my 8am class on the University of Colorado at Boulder campus when a student said there had been a terrorist attack. I turned on the tv in the classroom, and my students and I watched in horror as a second plane flew into the towers and the buildings began to crumble. I sent the students home and was able to quickly contact Kirsten and Brian, our older daughter and her husband, who lived in Manhattan. Fortunately, I was able to talk to them, although shortly after that all communication was shut down. Truly, no one had seen anything like this before.

We did not think we should go to NYC after such devastation, but all commentators were saying that the city needed tourists to come and spend their dollars. After careful consideration, we decided to go and did see Spamalot. On that trip, we were also able to travel to Ground Zero, where the ruins of the twin towers were still smoldering, although work had already begun on the clean-up. We truly felt a connection to NYC.

So, with those wonderful and frightening experiences of NYC, we were startled to learn on March 30th that a field hospital was being built in Central Park. As we watched it emerge, we took it personally. This was a marker of the toll the Coronavirus was taking on our society.

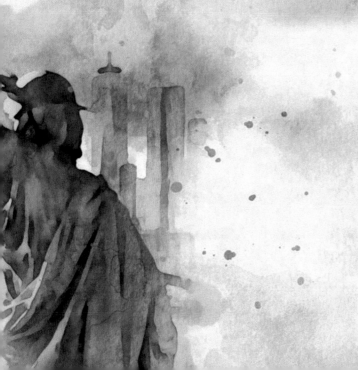

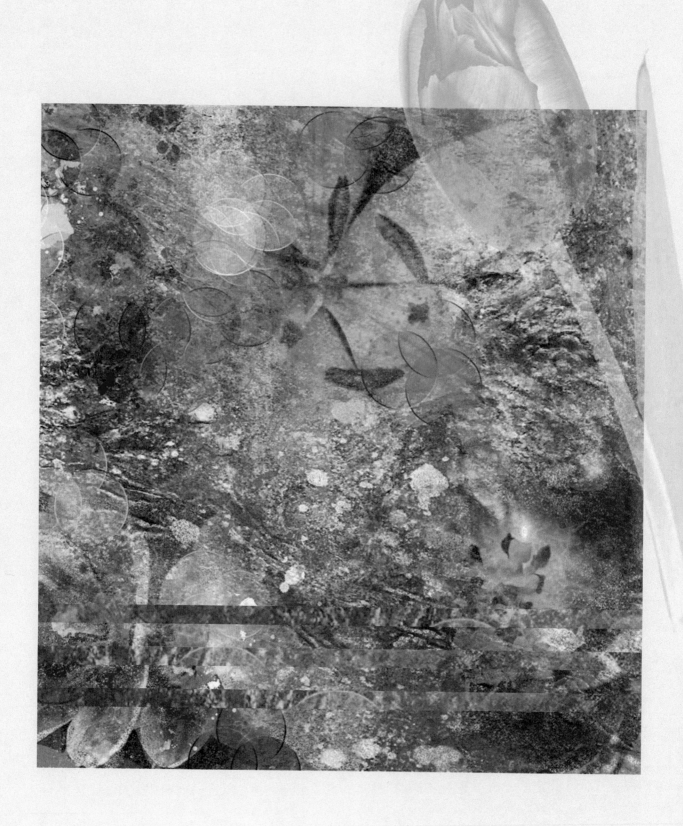

April/May 2020

it was the age of wisdom, it was the age of foolishness

April Fool's Day is April 1, but the whole month felt like an April Fool's joke. The kind of joke that some find funny, some groan, and some turn away in disgust. It did not seem very funny to me.

The daily routines we established in March were now firmly in place: staying at home, daily cleanings of our home with disinfectant, traveling to the grocery store for our one outing of the week, and using zoom to attend church and keep in touch with family and friends. In April, Dennis and I decided to play Cribbage each evening and keep track of who won, with a bet of a steak paid for by the loser. Our first date to end the game was May 1, and then May 15, and finally May 31st. We were still playing into the fall one year later.

Like most people our attention was on Coronavirus and the quarantine. News reports were all grim during April and May as the number of cases and deaths caused by COVID-19 continued to rise. On April 12th the White House Task Force on Coronavirus began their daily press briefings. Vice President Mike Pence chaired the task force and the members included Deborah Birx, coordinator; Anthony Fauci, Director of the National Institute of Allergy and Infectious Diseases; and Jerome Adams, Surgeon General of the U.S.

The press conferences often lasted two hours with sober and helpful advice given by the medical personnel. Then Trump would take the stage and in his rambling style would often suggest the opposite of what his task force had just recommended.

The guidelines for "flattening the curve," and preventing further spread of COVID-19 remained the same: washing your hands often, wearing masks

and social distancing when in public. Everyone could agree that it was a good idea to wash your hands often, but what was surprising was that wearing masks and social distancing in public were the two things that Trump refused to do and refused to do at the press conferences. Not surprisingly, they also became the flashpoint in the "culture wars."

Trump's emphasis was on "opening up the country," by Easter (4/13), but Easter came and went. Easter is a celebratory time in the Christian Church, remembering the death and resurrection of Jesus and the desire for new beginnings. In 2020, the celebration was muted by zoom worships and quiet reflection for the many deaths that had occurred: 47,000 in the US and 183,000 worldwide.

April though was not a time for quiet reflection. Conspiracy theories and protests against quarantines, wearing masks, and social distancing proliferated. Taking their lead from Trump, some men refused to wear a mask calling it "unmanly," some megachurches defied stay-at-home orders and held large worship services, and beaches in Florida remained open for students on Spring Break. Young people indicated, "they just wanted to have fun," while others protested their loss of freedom, brandishing guns to make their point. Trump, without any scientific backing and against task force recommendations, encouraged using bleach or the sunshine to eliminate the virus.

Maybe it is obvious how these months exemplified both the age of wisdom and the age of foolishness. Or maybe it must be stated clearly. The country seemed to divide itself by those who foolishly put themselves in harm's way, and those who followed the best advice of the scientists. Living through it felt like an exercise in stupidity and recklessness. For those who wanted to make wise decisions, it often felt like we were losing the battle if not the war.

By the end of May, the number of deaths due to COVID had exceeded the number of deaths due to natural causes, the Vietnam War, and World War I. By February 22nd, the number of 500,000 deaths was commemorated which exceeded the deaths of all of the wars in U.S. My mind could not make sense of these deaths, even after making the chart below. My sorrow over the unacceptable and preventable loss of life was often more than I could handle.

Particularly because I also sustained an injury to my left knee, which left me mostly incapacitated. I have arthritis in my knees, hips, and hands, and these areas were all painful throughout 2020. Then on April 29, I stepped off my bike wrong and by afternoon was unable to walk. It took me several weeks to understand what had caused the injury, all I

knew was that I could only walk with another person holding me up or with a walker. Our HMO Kaiser Permanente responded quickly so that I was given a walker and a physical therapist. After a couple of weeks, I graduated to a cane but still had intense pain in the joint. I continued rehab throughout the May and into the summer.

On the one hand foolishness, on the other wisdom.

CORONAVIRUS DEATHS COMPARED TO OTHER NATURAL/HUMAN DISASTERS

	A	B	C	D	E
1	Natural disasters				
2		date	event	number of deaths	
3		1871	Great Chicago Fire	300	
4		1906	San Francisco Earthquake	3000	
5		1927	Great Mississippi Flood	500	
6		1972	Black Hills (SD) Flood	238	
7		1976	Big Thompson Canyon (CO)	144	
8		1989	San Francisco (aka Loma Pietra) Earthq	63	
9		2005	Katrina Flood (LA, TX, FL, AL, MS)	1836	^
10		2013	The Colorado Floods	3	
11	Total			6084	
12					
13	Wars				
14		date	event	number of deaths	
15		1775-83	Revolutionary War	8000	
16		1812-15	War of 1812	2260	
17		1846-49	Mexican American War	1733	
18		1861-65	Civil War	214,938	
19		1917-18	World War I	53,402	
20		1941-45	World War II	291,557	
21		1950-53	Korean War	33,686	
22		1955-75	Vietnam War	47,424	
23		2001	Nine/Eleven	2,996	
24		2001-date	Afghanistan War	1,833	*
25		2003-11	Iraq War	3,836	
26	Total			661,665	
27					
28	Total wars, natural disasters			667,749	
29					
30	Pandemic deaths				
31		date	event	number of deaths	
32		1918-19	1918 Pandemic (aka Spanish Flu)	670,000	
33		1968	1968 Pandemic (aka H3N2)	100,000	*
34		2009-10	2009 Pandemic (aka H1N1)	12,469	
35		2020-date	COVID-19	150,000	* 7/1/20
36					
37	Total			932,469	
38					
39	^ no accurate number, this number probably too low, due to human not natural factors				
40	*deaths still occuring				
41	All statistics from Wikipedia				

A Good Friday

Legend says it was Friday
when Jesus nailed to a cross
cried, screamed, died.

His early followers fasted,
sobbed, mourned,
what was not to be.

Then saw beyond death
attested to new life,
named Friday good.

COVID-19 brought death
One hundred thousand.
Good Friday 2020

A single death, grievable
sister, daughter,
grandmother, friend.

We mourn, feel sorrow,
then lose feeling.
Grief meets incomprehension.

What is that number?
When Coronavirus is named good?

She Died on Easter Morn

Friends gather
 reflect on life, death,
 resurrection this Easter morn.
Their questions float over
 Mary's COVID death bed.
 Who was she? Where is she?
Separated by questions,
 they speak,
 "Why her to this horrible disease?"
What did Easter mean for Mary?
 Did you see her spirit leave?
 Will we see her again?
Where will her body be?
 A grave entombed, a niche cremated?
 Where will we find her?
Will she question the deep beyond,
 in her cynical, skeptical way?
 Did her mind-body fly too?

Spinning out in sorrow,
 they remember her,
 extravagantly smart, deeply spiritual,
 profoundly questioning, always annoying,
 she walked on the wind, her spirit flew away.
Bound together by questions
 unanswerable
 mystery surrounds them.
Coming together in grief,
 they cry, laugh, sob,
 feel the empty silence.
A collective shaking of heads,
 "We thought we knew her in life,
 We do not know her in death."
Weaving together in grief,
 they remember this day,
 An empty tomb, an ethereal presence,
 transitory time, ephemeral existence,
 let us break bread.

Coronavirus Compassion

A woman holds a Kleenex
to one nostril
as she steps to the side.
Virus escapes from only one.

A man roars by me on his bike
taking his side out of the middle
pores exuding sweat.
Virus left in his wake.

A woman wraps her silk scarf
around one arm
raising it to her face as we pass.
Her breathe lingering on the path.

Who are you behind that mask?
What are you thinking?
Do you want me to be sick
or just focused on yourself?

Who do you think I am,
behind this mask?
Do you see me?
Can we meet eye-to-eye?

Adventures await outside
or is it too dangerous?
Am I safe behind a mask
or safest in my own home?

A Poesy for Bunnies
Earth Day, April 22, 2020

Mountain cottontails romp,
leap, bounce, cavort.
Suburbia their playground.

Four weeks, teen bunnies play,
two years to death.
Still they rollick, frolic.

Adult bunnies consume,
reproduce, multiply.
Leisure a luxury, ever alert.

Relax in daylight.
Time is short.
Dash for cover, death close by.

Forged by fire, this goddess rises triumphant with her crown of golden light. Stronger than before, honed by life's experiences. Transformation is never easy—and all the more difficult for those who are perceived as "other."

Emerging from the Flames

Artist Statement: The worldwide demonstrations following the death of George Floyd and other black Americans touched me deeply. These events led me to examine both my white privilege AND what it means to be black in America and also led to a global examination of equality and justice. Watching thousands of multi-aged, multi-racial, multi-cultural demonstrators declare that "Black Lives Matter" has given me renewed hope that we can finally tip the scales toward justice and emerge into a world that fosters understanding for all.

June/July 2020

it was the epoch of belief, it was the epoch of incredulity

On May 25th, in Minneapolis, George Floyd, a black man, was murdered by a police officer, Derek Chauvin, who knelt on Floyd's neck for almost eight minutes. Floyd was being detained for allegedly passing a counterfeit $20 bill. Another police officer watched while Floyd struggled to breathe and then died on the street. The whole thing was filmed by 17-year-old, Darnella Frazier.

On June 2nd, my brother, Lloyd died. He struggled to breathe as well, as he had congestive heart failure. No one filmed his death.

George was the oldest of five children, two brothers and two sisters. Lloyd was the third of four children. Colleen and Manly were older than Lloyd and I was the youngest. Lloyd was 84 when he died and white; George was 46 and black. In most ways George and Lloyd were very different, but they will be forever linked in my mind.

Throughout June, outrage exploded over the death of another black person at the hands of the police, and sparked momentum for Black Lives Matter (BLM). BLM began in 2014 in Ferguson MO after the death of Michael Brown, jr. an 18-year-old black man shot by a white police officer, Darren Wilson. Since 2014 nine black men and seven black women have died at the hands of police, and after George Floyd's death, people, black and white, took to the streets. Night after night, demonstrations took place throughout the country, including Denver and Boulder, where I lived, and Des Moines, near where I was raised, and my nephew and niece still live. New conversations about race, discrimination, and structural racism became dominant in the cultural discourse, in ways that I had not seen since I started teaching Whiteness Studies at University of Colorado at Boulder more than 20 years ago.

Fascinating as this was to me as an academic and scholar of race and society, what was upper most in my mind was my brother. Lloyd and I were raised on the family farm in north-central Iowa. When Lloyd married right out of high school, he took over the farm and lived there even after the death of his beloved wife, Arlene. Then a couple of years ago, he moved to a near-by nursing home when his Parkinson's disease kept him from living alone. Lloyd was the only family member who remained an Iowan until his death, while the rest of us scattered to Colorado, Texas, and Wisconsin. Lloyd and Arlene raised two children, Mike and Lori, and she preceded him in death (1937-2004). Our parents (Ernest 1897-1979, Beatrice, 1903-1993), and our older brother Manly (1933-1991), also died before Lloyd.

George Floyd's funeral was held in Houston TX, where he lived, 10,000 people attended his visitation, including the governor of Texas, the mayor of Houston and Vice President Joe Biden. The Rev. Al Sharpton gave the eulogy. My brother's funeral was held at the funeral home, with only 10 people allowed to attended. In any other circumstance, Dennis and I would have packed up our car and driven the 750 miles to Iowa to attend my brother's funeral. But there was no funeral, rather a simple ceremony at the gravesite. Due to coronavirus concerns about flying or driving, I chose not to go but not without a depth of personal grief that I had not experienced when others in my immediate family died. "Being there" is how I perceive myself, and I chose not to be there, for good reason, but difficult emotionally.

Still there were highs as well as lows in June, because of the many celebrations that occur in the first two weeks. Our grandson, Calvin, turned 13, a teenager, on June 5th, our estranged daughter, Kirsten, turned 50 on June 11th, Dennis turned 80 on June 13th, and since our anniversary is on his birthday, we "turned" 56. So the first two weeks in June are always emotional for me. Not being able to celebrate Kirsten's 50 years further widened the hole in my heart that is always there. Calvin was excited to be a teenager, and we celebrated Dennis' birthday with a surprise zoom of friends. So June was joy mingled with pain and suffering.

The rest of June is a blur. Trump held his first rally since March 2nd in Oklahoma City (6/26/20), with thousands of people in attendance neither socially distanced or wearing masks following Trump's lead. Six campaign staffers tested positive to coronavirus and an flurry of cases in OKC were assumed to be a consequence of the rally. Still the "curve was flattening", we thought, until many states formerly with few cases now became "hot spots" as we moved to July: Florida, California, Alabama, Arizona, Georgia, Mississippi,

South Carolina, and Texas. Except for California, all of the other states were so-called "red states," who previously had not followed the CDC guidelines and were now suffering the consequences.

When will we ever learn?

Blacks are 2.5x more likely than whites by police to be killed per capita.
In 2019, Blacks were 13% of the population, yet 24% of all police killings.

Number of People killed by police from 2017-2020

	White	Black	Hispanic	Other	Unknown
2017	457	223	179	44	84
2018	399	209	148	36	204
2019	370	235	158	39	202
2020	204	105	66	15	116

Names of Black Women and Men Killed by Police since 2014*

2020-Breonna Taylor 26, Louisville, asleep in her own bed
2019-Atatiana Jefferson, 28, Miami, at home
2014-Aura Rosser, 40, Ann Arbor, threatening her partner with a knife
2015-Michelle Cusseaux, 50, Phoenix, at home
2015-Janisha Fonville, 20, Charlotte, at home
2014-Gabriella Nevarez, 22, Sacramento, driving
2014-Tanisha Anderson, 37, Cleveland, detained for bipolar

2020-George Floyd, 46, Minneapolis, passing a counterfeit $20 bill
2019-Stephon Clark, 22, Sacramento, in his grandmother's back yard
2018-Botham Jean, 26, Dallas, in his home eating ice cream
2016-Alton Sterling 37, Baton Rouge, selling CD, DVDs
2015-Freddie Gray, 25, Baltimore, arrested and shackled in a police van
2014-Eric Garner, 43, Staten Island, selling loose cigarettes
2014-Akai Gurley, 28, Brooklyn, walking downstairs in the building where he lived
2014-Tamir Rice, 12, Cleveland, playing with a toy gun in the park
2014-Michael Brown, 18, Ferguson, walking with a friend

*https://interactive.aljazeera.com/aje/2020/know-their-names/index.html

What if the same proportion of White women and men were killed by police?

Too Close to Home

Mid-afternoon, lazy day
an hour of horror.
Denny, Eric, Jody, Kevin, Lynn,
Neven, Rikki, Suzanne, Teri, Tralona
dead on blood-stained floors,
a pharmacy, meat market, deli destroyed
strewn tampons, stewed tomatoes, sushi.

Text messages of concern:
"Turn on the TV, a shooting near you."
Stunned. I watch, mesmerized
as just around the corner
police, drawn guns, scared victims
single file to safety.
More messages of concern
"Are you ok?"
"We were not there.
We're home safe."
"Do you know anyone inside the store?
Shopped there for 40 years.
Yes, we know them."

March 22, 2021
Ahmad Al Aliwi Alissa, 21 years old
drove from Arvada to Boulder
Ruger AR-556 pistol armed
entered King Soopers grocery store
shot ten dead.

This time is different.
Multiple mass shootings
Each death a scar.
Now ten more, too close to home.
Grief is sorrow close at hand.

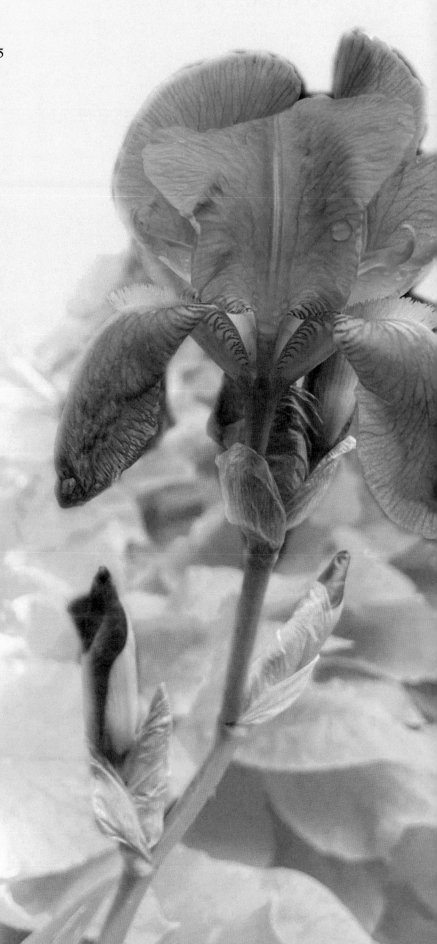

How long
must we wait?

A poetic rendering of Isaiah 11:6-9; 65:17-25

Sobbing, she says, How long, O God,
must we wait?

God answers.
Do you know how I work?
Do you know when I create?
Are you in charge?
I hear labored breath
see exhausted workers
feel overcrowded ICUs
know COVID-19.
With your labor pains,
I will midwife freedom.
Your heart evades truth
confuses revenge, reconciliation.
See wolves cavort with lambs
Hear mountain lions eat with deer.
Before you ask, I give.
Before you respond, I act.
The peaceable kingdom is here
in your midst.
If you have eyes to see
ears to hear, skin to feel.
Animals see what you miss.
And a child born in freedom
will lead you.

I am here, open your hearts.

No words left

We sit in silence
He in his Parkinson's
Me in my reticence
Or superiority
So little in common.

We sit in silence
Childhood memories
Tether us to reality
A few short years
Mined for meaning.

We sit in silence
Digital clock
Moves with glacial speed
He must stay, I may go
How much time is left?

Our lives spin separately
Occasionally touching
Our only commonality

Mother, father, brother passed
A tightrope across an abyss.

My days continue
His days numbered
I desire to be present
Waiting to leave.
We sit in silence.

I search for ideas
He searches for words
Desire conversation
Manage with chit-chat
We sit in silence.

Then his story ends
I sit in silence
Mourning my loss
Nothing to say then
Less to say now.

Memory Mind Fields

Boundless, no escape
Desolate landscape.

Eerie silence, careful footfalls
Step over, step around
A silent strike
Memories explode.

Physically unscathed
Spiritually wounded
Pummeled by
Multitudinous mementos.

Plummet to the depths
Events best forgotten
Resurrected.
Courage vanishes.

Immobilized, a pause
Momentary relief
A hesitant step
Another memory explodes.

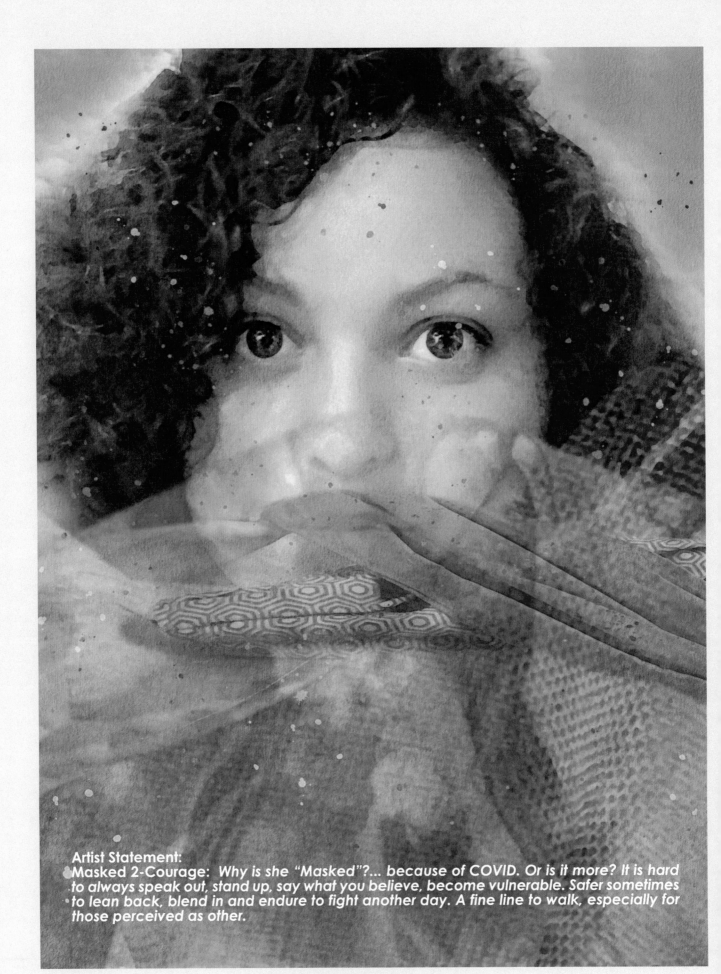

Artist Statement:
Masked 2-Courage: Why is she "Masked"?... because of COVID. Or is it more? It is hard to always speak out, stand up, say what you believe, become vulnerable. Safer sometimes to lean back, blend in and endure to fight another day. A fine line to walk, especially for those perceived as other.

August/September 2020

it was the spring of hope, it was the winter of despair

*O*ur lives settled into a ritualized routine: weekly visits to the grocery store, endless games of Cribbage, walks in the park, nightly viewings of British detective series on Prime, zoom meetings and church services, and occasional meetings in a park with selected friends, masked and socially distanced. The question, "When do we return to normal?" seemed increasingly irreverent.

In September, schools re-opened sort of. Some schools around the country had in-person learning, but most attempted a hybrid approach with days in person and alternate days online. By the end of September though, almost all schools, including universities, went to online learning. This presented the unique challenge of college students sitting in their dorm rooms and using their computers to go to class. The University of Colorado was not an exception due to a rise in COVID-19 cases in Boulder. Many students used their free time to party, usually without safety precautions.

Sports also had an uneven course through the pandemic. In professional basketball, teams quarantined together in a bubble, so that games could be played without fans. Football was an on-again, off-again affair with fans and athletes clamoring to play amid rising infection rates. So football was on, and then athletes tested positive, and games had to be cancelled. CU played in a league where the games were to start in November rather than August.

Campaigns for President were in high gear with large outdoor gatherings for the Trump campaign and small intimate ones for the Bidens. True to form Trump didn't wear a mask or require social distancing at these events, while Biden did.

The House of Representatives kept sending a coronavirus support bill worth trillions of dollars to Senate, and it sat on the majority leader's desk. And then, to compound all the despair that seemed endless already, Ruth Bader Ginsberg died on September 18th.

Ruth Bader Ginsberg, or as she was affectionately known RBG, had pancreatic cancer and had survived multiple cancer treatments and hospital stays always returning to her job at the Supreme Court. As she shrunk in size, she grew in stature and hoped to live until after the election. While the Supreme Court justice lay in state at the capitol, only the third woman and first Jew to do so, Trump sent his nomination for Ginsberg's seat. McConnell, the Senate majority leader, promised to push it through the Senate before the election. Of course, he did not do the same for Obama and held his nomination for almost a year, until Trump was elected. Shameless!

By the end of September, Boulder returned to the "red zone", which means that our cases increased to 350 per 100,000 and the positivity rate between 5-10%. Still Dennis and I remained healthy and reminded ourselves daily how fortunate we were: we don't have children that need home schooling, we have adequate food and shelter, we were able to manage our anxiety and our stress relatively well, and we still lived in close proximity without doing damage to ourselves or each other. We were so fortunate.

Yet we mourned for all those for which these things weren't true. How did parents manage a full-time job, working from home and still monitor these children's learning? How did those with addiction and other mental health disorders maintain their lives and manage?

As if that were not enough disasters for 2020, wildfires roared through CA and CO, doing unimaginable damage. In CA, 4 million acres burned, with 31 fatalities and 8500 structures damaged or destroyed. Although somewhat less in CO, we had four wild fires burning during most of this time with over 105,000 acres burned, with the largest wildfires ever. Most of these fires were still burning in October, and the air quality ranged from good to stay inside because you can smell the burning smoke.

It was difficult to find the hope, easy to be in despair.

The watcher

lavender rocking chair
potted deck flowers
brilliant afternoon sun
restless discordant clouds
distant children's giggles
tender breeze tiptoes by
god's stillness

clouds gather, converse
criticize the light
wind flogs trees
vindictive sky
rain tramples grass
people scatter
god's force

dark overcomes light
light baptizes dark
rainbow appears
god's grace

I see you, World

I see your design, World
Betelgeuse (Beetlejuice) star
Peace rose
Shiitake mushroom
your beauty, your ugliness
growth decay
evolution chaos.

I hear your sounds, World
Thunder clap, lightning crack
Common sandpiper wheet
Screaming nor'easter
your melody discord
modulation vibration
resonance destruction.

I smell your essence, World
Fresh pineapple slices
Mildew mold sulfur
New-mown hay
your pungent aroma
fragrance stench
full-bodied scent.

I taste your palate, World
sweet sour salty bitter
Grapefruit pith
Orchid producing vanilla
Freshly cut asparagus
sage mint catnip
astringent honeyed.

I feel your liveliness, World
Decaying oak leaves
Spring garden sprouts
Silence
heat passion frigidity
pain suffering anguish
desire indulgence joy.

I experience your heart, World.

A Lonely Introvert

Small talk,
room with no corners
too many people
trapped.

Genuine feelings
shared thoughtfully.
Friend distracted
nonchalant response.

Reveal self,
suffer regret.
Confined spaces
reduce fear.

Solitude tempts
privacy lures
seclusion coaxes
retreat beguiles.

Duties
commitments
obligations
quashes aloneness.

Plumb one's depth
share discretely
intensify the moment
loneliness diminishes.

Sadness without tears

Cathartic tears,
not for me.
My pain builds in the stomach,
the lungs, the heart. My back.
No release, only sorrow.

Why am I so different?
Tears spilling over, gushing forth,
face in anguish, not for me.
Just an awful ache.

Sorrow lives differently in me.
Others find relief in tears,
expressing the grief.
Not for me.
Do tears wash away the sadness?

Why am I so different?
Do others suffer in silence,
feeling so alone, so solitary?
Why are tears not for me?

What is Poetry?

Notice the small, awaken
Observe the hidden, perceive
Attend to the unusual, discern
Experience body sensation, express
Summon the sensual in the mundane, heed

God's Poem

For we are God's poem* created in Jesus Christ to do good works, which God prepared in advance for us to do. Ephesians 2:10

Am I a number, am I a disease
am I a longing, am I a thought?
No none of these.

I am a multiverse, a mixed metaphor
a living, walking thoroughfare.
Oh so religious, so secular.

A delicious wine, a piece of sushi
even a rotten egg, like balut.
As mom would say, she's a doozy.

Here's what I am: God's poem,
hurled into a hurting world.

*Poemia-Greek for workmanship, English words Poem and Poetry come from this word, literally means "something made," but usually translated as handiwork.

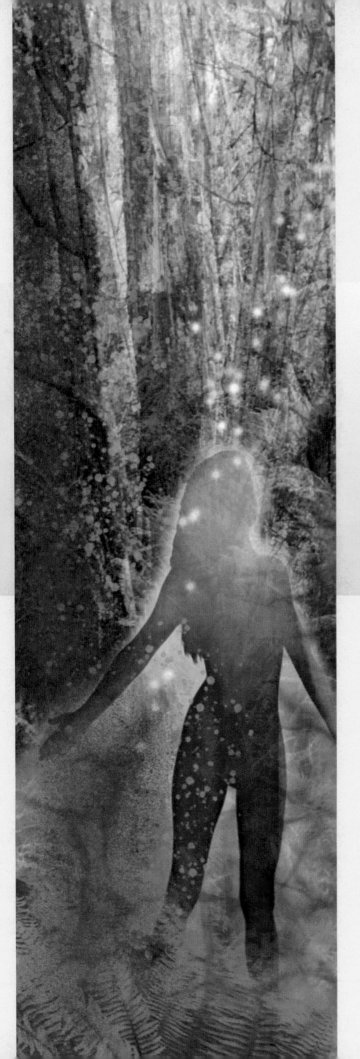

Healing Mother Earth

Artist Statement: Earth represents grounding and an attunement with mountains, plains, forests, oceans and all that gives us a firm footing to move forward. Because we "Stayed at Home" during COVID, we provided a much deserved opportunity for Mother Earth to rest and heal. Perhaps this experience will lead to a greater exploration of ways to ease the global crisis facing us and secure the health of our planet for future generations.

October/November 2020

we had everything before us, we had nothing before us

*D*ickens published, *A Tale of Two Cities*, in 1859 in Victorian England. Although the times and places differ, the issues were eerily the same: a disastrous retreat in Kabul after the annihilation of an Army unit in Afghanistan, the rise of evangelical Christianity and a movement away from religion, reforming the police to prevent crime, reform of parliament for more democracy, hideous slums, child labor, and a very strong enlightened anti-slavery movement (from Wikipedia). Remove the date and the issues ring true for our times.

At the beginning of October, we had everything before us: My 81st birthday. Thanksgiving. Unprecedented election with larger vote totals than ever before. The Biden/ Harris ticket won with 51% of the votes out of 81 million votes cast. There was also on the horizon a vaccine that would immunize the population against the Coronavirus.

We had nothing before us: Rising COVID rates, including the highest day of cases ever on the first day of November. The Trump/Pence ticket received almost 47% of the votes and 75 million votes. Trump refused to accept the final count and began a series of court challenges to overturn the election on the basis of voter fraud. Finally, the month ended with the death of a very close family friend.

The first of October Donald J. Trump, his wife, Melania and son Barron, all tested positive for Coronavirus. After spending several days in Walter Reed Hospital, with the latest in high tech treatment and drugs, Trump emerged October 5th proclaiming he had defeated COVID-19 even as 40,000 new cases were reported that day. He was ready to jump back on the campaign trail, so cable news channels spent more time on the contest for president and less time on the ever climbing coronavirus cases.

Trump held large political rallies with little social distances and masking. By contrast, Biden held small drive-in events, where people stayed in their cars and honked their horns at applause lines. Pundits tentatively reported that Biden would win the election but were reminded often how wrong they had gotten it in 2016. I still have PSTD from the night everyone thought Hillary Clinton would win the election. As more and more states announced their verdicts in 2016, Trump won. So I refused to get excited about the Biden-Harris ticket becoming president and vice-president.

On November 2nd, I turned 81, and the 2020 election was the day after. I tried to stay away from the TV unsuccessfully and as the day moved into evening, the networks were slowly beginning to acknowledge that Joe Biden was President-elect. The news anchors refused to call the election that night though and waited until the Associated Press called it on November 7th.

By the end of the tally, Joe Biden had received over 80 million votes, whereas Trump had received almost 75 million. The most votes ever cast in a presidential election, the most votes ever received by a presidential candidate and an electoral count that matched the one that Trump had trumpeted in 2016 as 'winningest," Biden 306 and Trump 232 with 270 electoral college votes to win.

President-Elect Joe Biden, who had run for president twice before and served as Vice President for two terms in the Obama administration, and Vice President-Elect, Kamala Harris whose mother immigrated from India and father immigrated from Jamaica hit the ground running. Top of the agenda: how to make a difference in the pandemic numbers.

For several days, after the election the only Trump sightings were on the golf course. After that the rest of the month he and his allies were interfering in the states counting of votes, asking for re-counts and then re-re-counts in Wisconsin and Georgia. By this time, he had already given up on making a difference on the coronavirus pandemic and was completely focused on overturning the election through questioning whether it had been fair and legal.

We celebrated Thanksgiving quietly with our daughter and a friend. A few days before that our good friend Val called and said that her husband Wally was having symptoms that were frightening, and they were making doctor's appointments. Wally was our first pastor at First Christian Church of Boulder when Dennis and I returned from the Peace

Corps and settled in Boulder for him to go to school. Wally was our pastor for 15 years, and then moved to Albuquerque to work for the New Mexico Council of Churches, and we stayed in touch. For over 50 years, we had not only been pastor and parishioners, but friends and colleagues. I loved to talk to Wally about theology and politics. The four of us would take long walks, go to movies, and have conversations over meals at home and in restaurants, which we had just done in February. Wally collapsed on November 27 at home, taken to the hospital where a scan revealed a massive, metastasized brain tumor. Fortunately, he did not linger and died on the 29th of November.

It is not easy to be sanguine, when the cyclical tides of the pandemic returned with a vengeance. It is not easy to be positive, when rushing to the bedside of a dying friend is impossible. It is not easy to be optimistic when the usual holiday Thanksgiving feast with 20 is pared down to four. It did appear that nothing was before us and difficult to see clearly everything that was before us.

It was not hard though to be thankful. During the beautiful fall days, we met our trainer in the park and did our exercises around beautiful Viele Lake. We still went out to buy groceries weekly, and Dennis took occasional trips to Home Depot to do small projects, like building boxes for our daughter's flower gardens.

AS COVID-19 encroached ever closer to friends, we eagerly gave thanks for the health care workers on the front line. As memories flooded and overflowed my mind of our family friend, I remembered with gratitude the many years we had shared. As our daughter and a close single family friend gathered around our scaled down repast, our love for our chosen family increased exponentially. As we gathered in our zoom windows, we were reminded of our beautiful grandchildren and how much they have grown and changed in this COVID year. Although we are unable to predict the impact on them and their generation, what I do know for sure is that my beautiful granddaughter and grandson have grown in love, empathy, and appreciation for what they have. These gifts will serve them well, and they have everything before them and their generation.

The Prophet
In memory of Wallace Ford

Biblical prophets
speak for God, call down judgment
turn over tables in the temple,
rail at false gods in
comfortable flowing robes. Repent!

They still walk among us.
He looked the part
grizzled, craggy face,
spindly body, steadfast presence,
eyes probed your soul.

A prophet for our time, his sonorous voice
railed against the Vietnam War
against the "isms," turned tables on the entitled.
Called down judgment in
comfortable jeans, flowing shirt. Repent!

He played Jesus one Lent,
lugged a hunk of wood
between make-shift stations of the cross.
He bore our burdens, carried our sorrows,
COPD rewarded his smoking sins.

Though each breath a struggle
all was well with his soul.
A philosopher, peacemaker
pilgrim, pastor
prophet, not a saint.

The "land of enchantment" his home.
Its fertile desert landscape his heart.
Prophet of the imagination.
Spokesperson for the dreamer.
Meditator between this promised land and the next.

Stumbling into Groundlessness

My spirit's lost
Who will find me?

Magical god pulls out the rug
I scramble like a cartoon character.

Shapeshifter god plays funny tricks
Stands firm beside me, disappears.

Superhero god saves my day
Muscles expanding, mine atrophy.

Companion god holds my hand
Chat as we step into a big rut.

Pathfinder god points the way
Eye on the horizon, the abyss awaits.

Metaphors die
Tropes terrify
Symbols suffocate
Parables stagnate.

No security
No stability
No permanent solutions
Clinging is useless.

Published in *Soul-Lit:A journal of spiritual poetry*, Winter edition 2021, www.soul-lit.com

The Trinity

God strides forward
His broad back, strong shoulders
Gentle adventurous leadership
Risk whispers anticipation, excitement
I hold my breath, expect more
I follow.

God walks beside me
Her hand in mind, soft tonal speech
Tell stories, sing songs, laugh out loud
Seductive mystery, enticing allure
I breathe intensely, want more
I enjoy.

God thrusts onward
Non-binary tattooed on their body
Art, music, poetry, dance,
Creative, thoughtful, seriously joyful
I breathe with purpose, desire more
I feel.

Photo Credit Barbara Mitchell Hutton

Not Today, Satan

"There's a moment in every day that Satan cannot find."
William Blake, poet
"Not today Satan, not today." Bianca del Rio, drag queen

If only you were dressed in red
If only you had horns on your head
If only you believed in sex
If only you had left a hex.

No, you're a subtle demon.
Jovial, fun-loving, extroverted
No snake oil concoctions
Just addictive delicious highs.

If only you had a pitchfork in your hand
If only your arm had a swastika band
If only your teeth were bloody red
If only your feet were truly webbed.

No, you're a charismatic genius.
Smiling, thoughtful, introverted
No popular psychobabble
Just plausible mind games.

If only you had a long, dangly tail
If only you were macho male
If only you exuded evil
If only your throne were made of fecal.

No, you're a sneaky little devil
Smart, wise, head leveled
No appeal to my better nature
Or clever use of nomenclature.

Where is that moment of which Blake speaks
When all around us havoc wreaks?
Is that moment filled with naught
Or does god step in where you are not?

It's not easy to discern
In any momentary decision
The saintly, the divine
The wicked, the very wrong.

So with Bianca I say
Satan, not today
A prayer to ward off evil
Embrace a moment of cathedral.

Published in Soul-Lit: A journal of spiritual poetry, Winter edition 2021,
www.soul-lit.com

December 2020 - February 2021

we were all going direct to Heaven,
we were all going direct the other way.

*O*peration Warp Speed: maybe we were going direct to Heaven, maybe a light at the end of the tunnel.

In March, a public and private partnership, Operation Warp Speed, put together a plan to create a vaccine against the novel coronavirus, to distribute 300 million safe and effective doses of the vaccine, and to start vaccinations by January 2021. The Department of Health and Human Services and the Department of Defense would work with private firms and federal agencies to accomplish this seemingly impossible task. The first company given funds was Johnson and Johnson, then Moderna, AstraZeneca, and then finally Pfizer in July. Over $12.4 billion had been spent by December, and on December 14 the first vaccine, Pfizer, was shipped and the first person vaccinated.

The vacinne required two doses and the need to be stored at -70 degrees Celsius (-94 Fahrenheit). The second vaccine, developed by Moderna, became available on December 18, which was a one dosage vaccine, and stored at -20 Degrees Celsius (-4 Fahrenheit), which is standard for most hospital and pharmacy freezers.

On January 21st, Dennis and I received our first vaccination and our second on February 18th. Since we are considered vulnerable populations, we were at "the front of the line" to receive vaccination. Still though, some of our friends and relatives had not been vaccinated.

COVID-19 continued to surge. 201,073 cases and 2500 deaths on December 14. On Thanksgiving people were generally not following guidelines as well as they should have, and the numbers rose dramatically. After a vaccine was announced, many people took that as a license to return to more

"normal" activities for the Christmas holiday, travel, gathering with family and friends and celebrations. On February 22nd, President Biden and Vice President Harris stood on the steps of the White House and commemorated the death of 500,000 Americans due to the Coronavirus.

On February 27, a third vaccine, Johnson & Johnson was approved with only a single shot needed. It could also be kept at the usual temperature for other vaccinations, and President Biden predicted that all U.S. citizens who wanted a shot would receive them by mid-May.

Overlaid on this very hopeful scenario were other events that felt like we were going "the other way." On December 14 the electoral college officially elected Joe Biden President-Elect and Kamala Harris Vice President-Elect. A day of celebration. Of remembering better times. Of feeling that we were on our way to heaven. But the endless winter was not over.

Hope was beginning to seep in that maybe with a new year, a new administration, things would change. Then January 6th! On that date, a very archaic ritual is enacted, a pro forma reading of electoral votes by the Vice President in the Senate chamber and the winner of the election announced, even though throughout our history there were only a few examples of interrupting this process.

Not in 2021. Since the election, Trump contended that the "election was stolen" and that he was the real winner, even though the actual vote count and the electoral college indicated a landslide for the Biden/Harris ticket. He brought lawsuits, held rallies, and press conferences. January 6th he held a rally at the Ellipse. Called the President's Park South, it is a 52-acre park south of the White House fence and north of the National Mall. Around noon, Trump urged his followers, at least 10,000 strong, to march to the Capitol, just over a mile away.

Many protestors listened to the speech and then wandered around the Mall, but a contingent with guns, sticks, riot and tactical gear, were determined to take over the Capitol building. For over six hours, the Capitol was desecrated as the mob wandered through the capitol looking for the Vice President of the United States, Mike Pence, and Speaker of the house, Nancy Pelosi, to kill them. These two people are second and third in line for the Presidency so it is unimaginable what would have happened had the domestic

terrorists succeeded. Or maybe it isn't, because Trump probably would have declared martial law and assumed the presidency for a second term. In addition, these domestic terrorists rifled through files, legislator's desks, smashed windows and broke down doors. Pence and Pelosi were rushed away by their security detail, and the rest of Congress sheltered in place until they could be ushered away to a safe site as well.

All of this happened in real time, while the America public watched tv. Finally, the crowd left the building and the National Mall, as curfew loomed. By 2am, the Capitol had been cleaned and restored, so that Congress could once again finish its constitutional duty.

Five people killed, but no arrests on that day. Since many in the crowd were proud of what they had done, taking pictures and posting to social media, the FBI started identifying people, arresting them, and charging them. It is hard to believe that domestic terrorism is not an actual crime. Instead the ringleaders were arrested on many other charges.

Then the week of February 8th, the Senate began the second impeachment trial of Donald J. Trump after the Articles of Impeachment were sent from the House of Representatives. The House Impeachment Management did an amazing job of showing in words and pictures the evolution of the invasion of the Capitol and how Trump incited it, but still only seven Republicans joined all 50 Democrats to impeach, and thus he was acquitted again! The only President to have been impeached twice and of course acquitted twice.

We were going direct to Heaven as more people became vaccinated and death due to Coronavirus declined, but we were also going the other way as our political future is still very much in doubt, as Trump will probably continue to be an important political force.

We Shall Not Forget

Incited by Trump, Giuliani, Don Jr.
Stop the Steal mob overwhelmed security.
Armed men, a few women
stormed our Capitol,
blew past barriers, climbed walls
broke glass, shattered doors.

Gathered to confirm 2020 election,
legislators crouched under desks
feared for their lives heard shouts
"kill Pence, kill Pelosi"
vandals, subversives, terrorists
raised arms, clenched fists.

Girded with phones, insurgents recorded
seemingly triumphant moments
gleeful smiles, stolen laptops
invaded offices, destroyed documents
desecrate, violate, dishonor.
A confederate flag in Constitutional Hall.

Two months after the election
voter fraud rejected by countless judges
Trump tweeted support for mob
criticism of Pence. Five hours mayhem .
crowd melted away, conformed to curfew.
No arrests, no detainees, five deaths.

Cleaning crew scrubbed stains,
nailed up windows, restored order.
Six senators still objected to win.
Electoral vote confirmed
fourteen hours late
3:31am, 1/7.

A reality show, a tv president
distracted by pandemic
conditioned to false equivalencies
thwarted by civil niceties
obsessed with the Bachelor,
we watched in real time.

Were grievances justified
wrongs righted
injustices rectified
by combat booted evil?
TV anchors named it
brutality, barbarity, atrocity.

This day will live in infamy
One-six, two thousand twenty-one.
akin to Twelve-seven, Nine-eleven.
This is how pandemic ended
powerlessness, inured to violence.
We shall not forget.

Indiscriminate Pandemic

Indiscriminate pandemic
accumulates dead bodies
young old, healthy infirm
overwhelm morgues
cemeteries.

No solace, comfort or consolation
Just interminable helplessness.
Brother, sister, pastor, friend
all died unattended.
The futility.

We stay healthy, while others fail.
We are warm, eat well
while others are cold, hungry.
We laugh while others weep.
I seem unafraid.

Outward appearance belies
inner impotence
submerged by sorrow
inundated by despair.
Overburdened.

Where is God in this mess?
Has she left us behind?
Must we be our own saviors?
If so, I have failed.
All is vanity.

It Is Well With My Soul

When peace like a river surprises, consoles
When sorrows like sea gulls cajole
Whatever may come, no matter the harm
I was taught, it is well, it is well with my soul.

When evil persistently triumphs
Ordeals come, not by half, but by whole
Knows my losses, a loved one speaks,
Listen, it is well, it is well with my soul.

Aretha announces a new day in song
While the old sinks into a hell of a hole
I believe, help my unbelief, a skeptic I am,
Even so, it is well, it is well with my soul.

Fall

A green, lobed leaf
uniquely segmented
securely attached to a bur oak tree.
Winds do not dislodge,
this tenacious child
clings to the branch.
Sun lowers in the sky
a chill in the evening
her garment changes
to golden brown.
Mother tree loosens
her grip, leafy child
fears the fall
favors the secure.
One day she lets go,
floats on the wispy breeze
amazing views
Eastern plains
Westerly mountains.
Her siblings a canopy above
soft landing below
blades of faded grass
tickle, support, sustain.
Letting go, in hindsight,
a pleasure, a reward
for coming adventures
Her rich colors fade
winds blow, rakes disturb
disintegration into pieces
mulch for her mother tree.

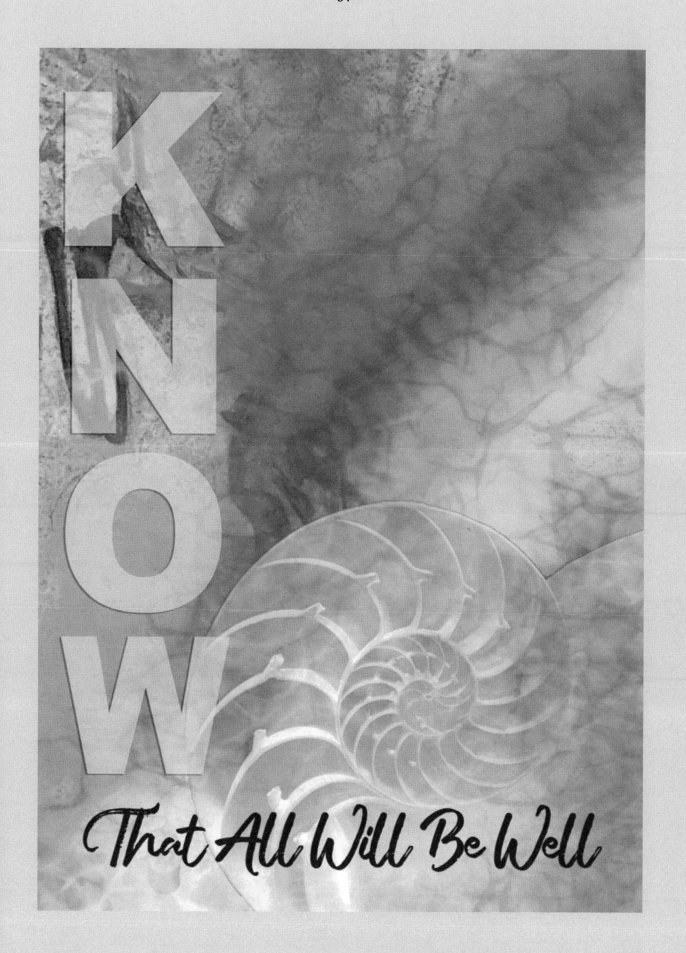

KNOW

That All Will Be Well

Dad was small for a man, about an inch shorter than his wife, but he had the strength and endurance of a much larger man. Six days a week, my Dad left the house before the sun came up and returned after it had already fallen off the horizon. His only time inside the house was to eat the three gigantic meals my Mom prepared every single day. Since Sunday was a day of rest, he would take a nap for a couple of hours in the afternoon, but he still had all of his regular chores to do. His exposed arms and legs at first glance appeared deceptively scrawny, but he could "wrestle" the farm animals, toss bales of hay into and out of the haymow, and lift a farm implement high enough to fix whatever needed to be fixed underneath. Nobody questioned Dad's strength, or his ability to work hard, no matter the season.

Dad had a suit which he wore to church on Sunday, but the way I remember him was the "denim uniform" he wore for everyday: a cap with a bill, a one-piece overall, and a long-sleeved denim shirt, buttoned down in the winter and rolled up in the summer. All the farmers I knew, including Dad, had farmer's tans. This meant that the skin he left uncovered while he was in the sun was tanned and leathery. I never saw my Dad undressed, but presumably all of his body was as white as his upper arms and forehead, where a farmer's tan line clearly marked where the tan ended.

Mom used to say that Dad could fix anything as long as he had a little baling wire: his tractor, combine, and planter, as well as all the other farm implements. But he also fixed my toys, my brothers' bicycles, and anything Mom asked him to. Dad was handy, and he enjoyed working with his hands, but the main reason he fixed things rather than buying new is because our family was poor. Mom used to say we were land-rich but money-poor. Another thing she liked to say, when the wind was blowing from the south wafting the smell of the pigs toward our house: "That's the

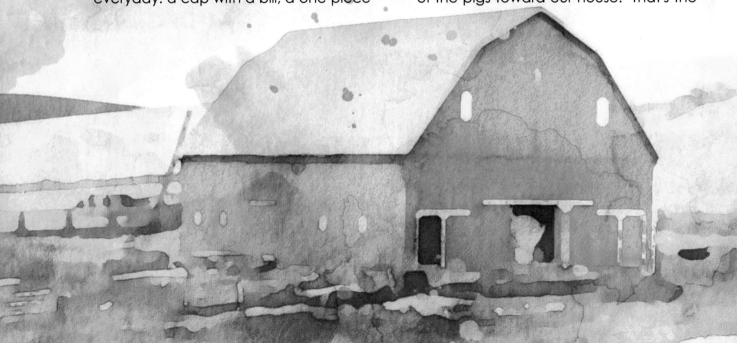

Resilience, Perseverance, and Grit
An Interlude

smell of money!" This really meant that all of the family's money was tied up in land and animals, and when there wasn't enough money left over at the end of each month, Mom would say, "We will make-do."

Making-do meant that our family fixed things rather than buying new. For instance, Mom always patched Dad's overalls and darned his socks. Darning means creating a weave of embroidery floss over the hole Dad had worn in the sock. She taught me to darn socks as well, and even after I married, I still darned socks. It also meant that we conserved and re-used things, long before the environmental movement preached these simple virtues. We ate only what we produced, which really meant that we often ate well, at least after I was born. Our farm produced plenty of animals to eat, but occasionally when one was not ready to be slaughtered, Dad would go

hunting. He would take his old rifle out of closet where he had carefully concealed it from his children and go shoot a pheasant or other wild game. Dad loved wild meat, but Mom didn't really like to prepare or eat anything "gamey," but "making-do" also meant in my family, you didn't complain. You sat at the table, usually weighted down with meat, potatoes, vegetables, salad, and homemade dessert, and ate what was prepared. No complaining allowed!

I came to understand my Dad better as an adult, but as a child, Dad was a mystery to me, maybe because he was a man of such few words. My first memory is of him sitting inside the barn milking his black and white Holstein cows. He could comfortably sit on a stool and put his head on the cow's flank, methodically pulling on each cow's tit until her milk bag was empty. Dad always looked as if he were at home there, unlike when he

sat in our well-worn living room or at church. He was a slow reader but he persevered, reading the *Des Moines Register* daily, and every *Life* and *Look* that came to our house.

Dad was calm and placid milking his cows each morning and evening, ignoring me and any other disturbances. However, on occasion, his animals or his sons wouldn't cooperate, and Dad would become enraged. He never struck them or me, nor even raised his voice with me, maybe because I was a girl. He frightened me anyway. He was awe-inspiring: his strength and anger, his will power and self-reliance, and his intense determination to achieve a better life for his children than he had himself.

Mom was tall for a woman, about 5'7", and on the farm, she dressed in inexpensive housedresses. By the time I arrived, she could afford to order colorful cotton print dresses from the Sears Roebuck catalog, rather than sew them herself. Topped by an apron in order to keep her dress clean for the occasional drop-in visitor, Mom's housedresses hung loosely, even though she had a nice figure, unharmed it appeared from birthing four kids.

For church, she would dress in more contoured, usually flowery dresses, accessorized simply with a stylish touch. Mom's accessories were a gold watch, given to

her by Dad; a necklace, usually strands of pearls; glasses; and her ubiquitous black purse. The first thing anyone noticed about Mom, though, was her astonishingly white hair. When I was a child, her uncut hair was worn pulled back into a bun at the nape of her neck, as was the tradition in her church. By the time I was in high school, her hair was completely white, and she went to the beauty parlor weekly to have it cut and curled, and then tinted blue.

Mom was smart and strong, but relied on my Dad, just as much as she must have relied on her own father. My mother told me that she had been a frightened child, as her father insisted that she stay away from anything he thought might be dangerous. So Mom was afraid of a long list of dangerous things, snakes definitely topping the list. I didn't know that one beautiful Iowa summer day. I was not yet in school, so I must have been four or five. At that age, I would not have played in the front yard alone, as Mom feared the cars speeding by in front of our house. I was playing, and Mom was probably hoeing her flower garden, when a snake slithered out from under the bushes in front of our house. I was fascinated and called Mom over to see it. Mom ran to me with a huge hoe raised above her head, and with one quick movement, chopped the snake in half. I remember thinking: "Why did Mom kill the snake?"

Later, I learned that Mom was so fearful of snakes that she wouldn't even look at a picture of one in a book. Mom believed in nonviolence for all living things; however, when it came to "protecting" her child, she was ready to kill one of her worst fears. Mom would have relied on Dad for protection if he had been close by, but she leapt into action when he wasn't.

At eighty years old, I am very aware of the slipperiness of truth. Memories of my childhood arrive on the doorsteps of my mind easily, but are they truthful? Particularly, are my memories of my dad and mom too colored by nostalgia? Do my memories elevate their optimistic attributes while neglecting their more pessimistic moments? Have I elevated them to a sort of "sainthood"? In struggling with these questions, I do realize how heavily influenced I was by them. As my story evolves year after year, Mom and Dad endure as major players.

Now I too have all white hair and like to make a statement by coloring my bangs purple. Mom made her statements in less obvious ways, and Dad would never had thought to bring attention to himself, but I did learn so much from them. Simplicity in life-style meant we were never poor. They taught me resilience, perseverance, and "grit," I do remember tough times, but mostly I bathe in their goodness, hope, and trust in a better future.

Resilience

Aware of chaos
aided by order

Conversant with conflict
enlightened by harmony

Close to dissension
intimate with peace

Informed by busyness
calmed by tranquility

Acquainted with grief
familiar with hope

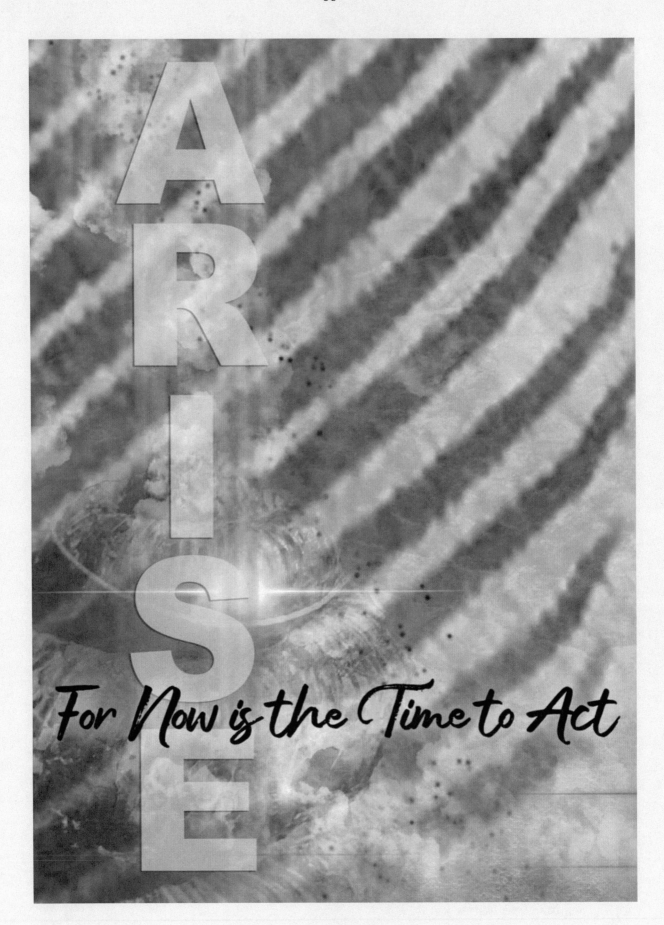

What do you want from me, God?
A poetic rending of Micah 6:8

He has shown you, O mortal, what is good.
And what does the LORD require of you?
To act justly and to love mercy
and to walk humbly with your God.

God, I screwed up. Again.
What do you want from me?
Confess my sins. Done.
Take my tv, my house, my IRA, my first born?
Destroy all my relationships?

And god said, don't be so dramatic.

God, where are you?
I look to nature, to animals
Others and myself.
A momentary shadow seen or felt,
Are you lurking or is it gas?

And god said, enjoy the moments.

The moment you take the next step
Acknowledge your loves and hates
Find tenderheartedness
In the midst of life's strifes.

And god said, I have shown you what to do.

Act with abundant justice.
Love with boundless mercy
Walk with infinite humility.

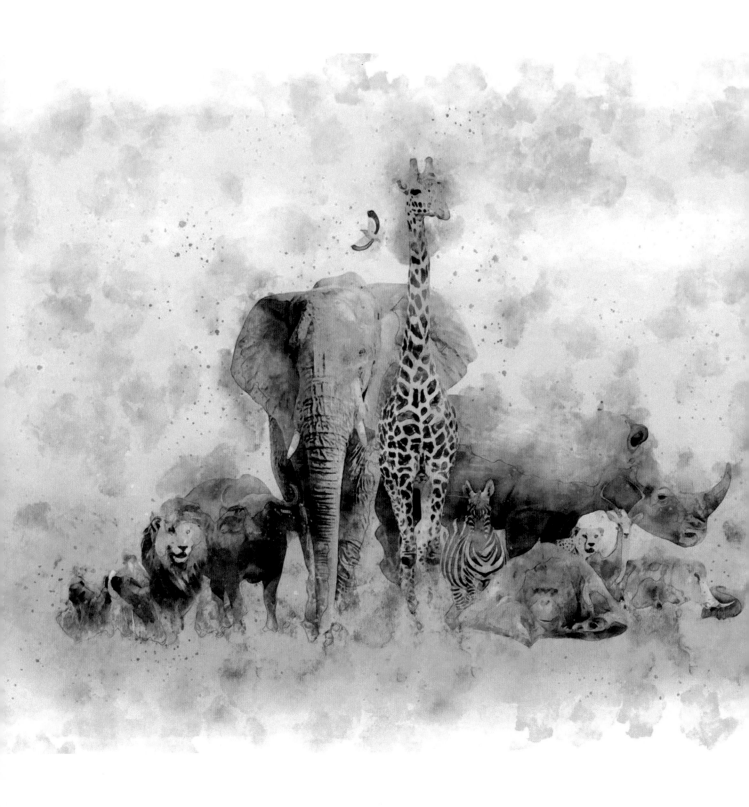

The Synod of the Critters:
An Emerging from the Flames Fable

it was the season of Light, it was the season of Darkness

Late one moonless night in a far corner of the earth, a large herd of critters gathered, spiritual leaders all. Each animal, an elephant, a hippopotamus, a lion, a wildebeest, a warthog, a giraffe, and a great ape had been invited as a leader of their tribe, but they were sad, lonely, afraid, listless, and without direction. The pandemic was waning, but they saw no way forward, though each had been sent by their tribe. They seemed like lost souls.

Ms. Flowers, a meerkat, mounted a dead tree stump, and a hush came over the crowd. She said, "Don't be anxious, there is someone far away who will lead us out of our misery. Even though this is a long and difficult journey, through valleys and deserts and over mountains, if you go, you and your tribes will be forever changed. The Sage waits for us."

All the critters were excited and began their preparations for the long trek. Ms. Tusk, the elephant, packed her trunk. Mr. King, the lion who all the critters called ARNB (all roar, no bite), practiced chasing Mr. Beast, a wildebeest, around the valley. Mr. Wart, the warthog, knelt in prayer, giving thanks for what had brought him here, and Ms. Nubia, the giraffe, looked up to the heavens and prayed for a hopeful outcome to their adventure. Mr. Pop, the hippopotamus, wondered where there would be enough water for him to submerge himself. It was only Ms. Bono, the great ape who was all ready to leave, and watched the others smiling at the frenzy.

Early the next day, trumpets, screams, bleats, screeches, roars, growls, purrs, and snorts filled the air as the critters waited for Ms. Flowers to say, "Let's go." But she was huddled with Mr. Beast, who felt lethargic. "Our herd has travelled every day to migrate across this great land. I'm tired, so I will take care of myself in this beautiful meadow and catch up with you tomorrow."

Ms. Flowers responded, "How do you know tomorrow will come? Did all the critters who started make it here? Everyone is tired, but each has found a way to be here. You will too, if you but start the journey, now, with all of us." And thus with Ms. Flowers in the lead, they left behind the Ravine of Lethargy, enjoying the Meadow of Enthusiasm. They ate till they were full.

By noon, the sun was hot, the climb out of the canyon became harder, and each felt hungry. Ms. Tusker and Mr. Pop, not natural friends, slowed down until they were at the back of the pack. They had packed their trunks full of necessary items, afraid to leave anything behind, but now they were feeling melancholy. As they slowed to a stop, the herd realized that their possessions which felt so necessary before, now were feeling very heavy. Ms. Flowers said, "Do not let your attachments and addictions hold you back. You must let them go in order to see the Sage." Ms. Tusk took the lead and emptied her trunk. Ms. Nubia removed the jewelry from around her neck, ARNB and Mr. Beast dropped their satchels of precious mementos, while Mr. Wart and Mr. Pop left their meds behind. Only Ms. Bono had traveled unencumbered and urged the others to remember why they had set out on this journey. As each left their burdens behind, so too they left behind the Canyon of Melancholy and Addiction and emerged into the Pasture of Delighted Detachment.

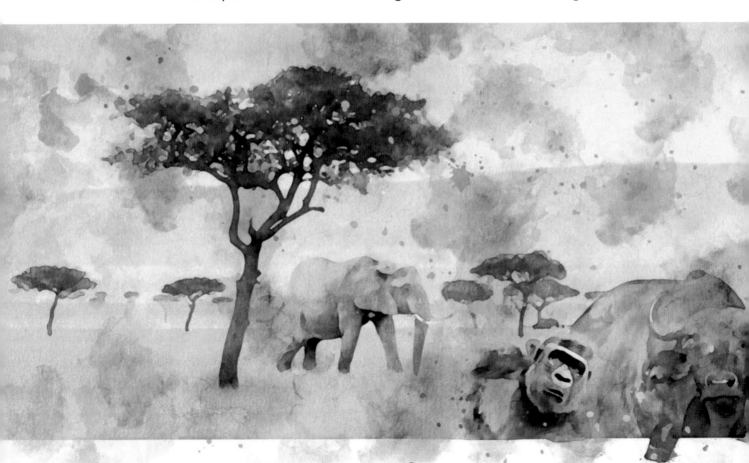

Unencumbered with their things and their tummies full, the herd started up the incline and began to experience their fears more intensely. As they topped the rise, they clearly saw what they had only intuited, that a storm was brewing. The skies grew dark, the wind began to roar, and Mr. King lingered until he was at the back of the pack. Both he and Mr. Beast began to tremble with fear. They no longer playfully chased each other but crouched behind a big tree, hoping they were out of sight. As Ms. Flowers approached them, ARNB said, "I hate thunder and lightning. Surely we are safer here than out in the open meadow." Mr. Beast concurred, "We can wait out the storm here, and then proceed."

The other animals began to make fun of the lion and wildebeest, "You are sissies! We knew you were all roar and no bark." Ms. Bono stepped forward, "Brother King and Brother Beast. Fear not, we are all in this together." Mr. Wart prayed for them to find their courage. Mr. Pop said, "I'm afraid too, but we each have the strength we need. Let's go together." Ms. Flowers smiled and sat holding their paws, "Do not let your doubts destroy your chance to go on this journey. Release your fears, find your faith and courage now." And so the timid lion and the put-upon wildebeest hurled themselves into the Storm of Fear relying on the Warm Summer Rain of Trust to carry them through.

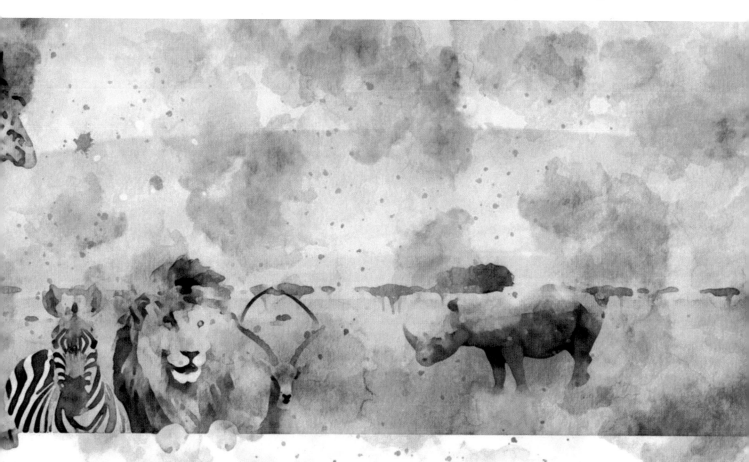

As the storm subsided and the sun re-emerged, the valley ahead looked new and fresh. Yet to come was the Desert of Vanity, Valley of Disillusionment, and the Mountain of Violence, where they lost Ms. Tusk to poachers. They remembered her kindness, her gentleness, and her ability to keep the herd together, so they all shouted, "Together for Ms. Tusk." Relying on each other and humbled by the journey, they discovered the Oasis of Humility, the Peak of Intimacy, and the Summit of Truthful Kindness.

They were in awe as they rested on the beach and gazed at the Ocean in front of them. Mr. Pop was of course delighted and began to wallow in the water, but Ms. Nubia began to whine, "How much further? I thought we were there!" Ms. Flowers answered, "If we have endured all of these days and even lost one of our own, then we have the strength to meet any challenge and continue on for another thousand miles. The Ocean of Impatience must be traversed to find the Island where the Sage lives."

The sky was bright blue as was the water, and they plunged into it. Ms. Nubia was still impatient and galloped ahead and soon disappeared into a thick band of mist. The mist was so thick that the giraffe could not see the other animals behind or the island ahead. "Am I going the right way?" she wondered. Confused she ran faster while becoming more desperate, until Ms. Nubia stopped. Her desire to be the first to see the Sage was for naught, and she realized, "I have made a terrible mistake. Without the herd, I am lost." Ms. Flowers then appeared out of the mist and said to the giraffe, "We have learned to lose ourselves to be what we must be. You have passed the most difficult test of all and learned patience. Now that we have found each other again, let us complete the quest."

The mist dissolved, and they all were on the Riverbank of Calmness. Nobody greeted them, no Sage. As each approached the water, all they saw was their own reflection.

Then Ms. Flowers shared her final thoughts, "I know you came thinking you would find someone wiser than you to help you and your tribe find a new way forward. But the Sage is not of this earth. She's the wisest One of all creation. She can see your hearts and know that they are like this pond. None

of us can ever see the light of truth within, unless the mirror of our heart is free of dust and sin. We have each had to shed our flaws and find inner peace. Now we will be able to see the Sage."

The clouds vanished, the sun lit up the pond, and no one could see their own reflection anymore. There was no thought of me and you or this and that, but each found themselves in the loving embrace of the Other, God, the Sage. They were in the Pond of Unity. As they enjoyed the moment, they also knew they were ready to return home and share the wisdom they had gained at the synod of the critters.

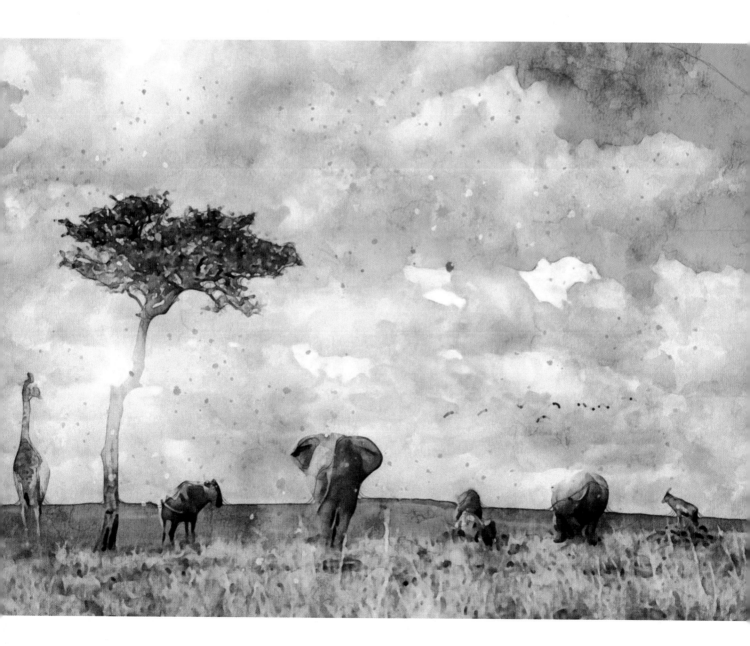

About the Author

\mathcal{D}r. Eleanor A. Hubbard is a retired sociology professor at the University of Colorado Boulder, specializing in race, class, gender, sexual orientation, and sexuality, a diversity trainer, and a long-time member of Cairn Christian Church in Lafayette CO. Throughout her life, she has pursued her peace and social justice concerns through teaching, writing, and community volunteerism. Eleanor's memoir, published in 2010, *Finding My Way Home: A remembrance nest of farm, family, and faith*, tells of her Iowa childhood and how those influences contributed to her life perspectives. Her other published work in 2012 was the ground-breaking *Trans-Kin: A guide for family and friends of Transgender People* with co-editor Cameron T. Whitley; a collection of stories about living with and loving trans folk. Turning eighty shortly before the pandemic, Eleanor's reflections on her life, her career, her faith, and her spirituality intensified as it emerged from the flames.

About the Artist

*P*amela McKinnie is a painter and sculptor best known for her mixed media paintings, which are multi-layered, brightly colored and intensely textured. She is an intuitive painter whose style is influenced by Rassouli's Fusionart, which makes the unseen visible in unique ways, and the symbolic, dream-like quality of surrealism. As a graphic designer for 35 years, she has designed and illustrated more than 50 books for indie authors. Her fine art has been accepted to prestigious art shows, galleries, museums, public art installations, and solo shows both nationally and internationally. (Take a look at the following list of juried shows to see some of the awards presented to the art included in this book.)

In describing her art she says, "My art is a reflection of what is felt rather than what is seen. I hope to create something that is alive with energy and invites each viewer to connect with life in new and meaningful ways."

Index

Juried Art Shows

Juried Art Shows, Pamela McKinnie

Emerging from the Flames shown at 10 juried shows in 2019-2021:
"The MUSEA: International Creativity Museum" accepted Emerging from the Flames to their museum show entitled "Women Woven Together" March 26, 2021

"2021 14th Annual CVG Show at the Collective Visions Gallery in Bremerton, WA" held January-February, 2021

"International Art > 70" show hosted in Taranaki, New Zealand, December 2020

"Artavita Exhibition" with the theme COVID Dreams, November 2020

"Fall Arts Walk" solo art show at Dancing Goats Coffee Bar in downtown Olympia for the month of October, 2020

Selected by the Shelton Arts Commission for the August-October, 2020 Shelton Civic Center Rotating Art Gallery solo show

SLMM (International Society of Layerists in Multi-Media) June 2020 juried show

Juried "Museum Contempo show, Fusion V: Unity in Diversity" spring show

Thurston County Juvenile Justice Center, solo exhibit. August-October 2020. Selected by committee of judges, county commissioners and artists.

Juried "Celebration of Light! Who is God VI" Museum Contempo show, September-December 2019

Faith in Our Future shown at 7 juried shows in 2019-2021:
"Fall Arts Walk" solo art show at Dancing Goats Coffee Bar in downtown Olympia for the month of October, 2020

Selected by the Shelton Arts Commission for the August-October, 2020 Shelton Civic Center Rotating Art Gallery solo show

"Fusion Art 4th Annual Skies Art Exhibition," August 2020

ISEA (International Society of Experimental Artists) 29th Annual Juried Exhibition, August 2020

Juried "Museum Contempo show, Fusion V: Unity in Diversity" spring show

Thurston County Juvenile Justice Center, solo exhibit. August-October 2020. Selected by committee of judges, county commissioners and artists.

Juried "Celebration of Light! Who is God VI" Museum Contempo show, September-December 2019

Healing Mother Earth shown at 3 shows in 2019-2021:
"Fall Arts Walk" solo art show at Dancing Goats Coffee Bar in downtown Olympia for the month of October, 2020

Selected by the Shelton Arts Commission for the August-October, 2020 Shelton Civic Center Rotating Art Gallery solo show

Juried "Celebration of Light! Who is God VI" Museum Contempo show, September-December 2019

Masked 1—Resilience shown at 6 juried shows in 2021:
"2nd Half 2021" juried exhibition held by the Las Laguna Art Gallery, Leguna Beach, CA, July 2021

"Diversia: People" juried exhibition, July 1-31, 2021

"Museum Contempo Fusion VI Installation" show held May 1-June 27, 2021

TRA Medical Imaging public art display May-July, 2021

"New York Artexpo" April 22-25, 2021. International fine art trade show.

Olympia, WA public "Spring Arts Walk," April 2021

Masked 2—Courage shown at 5 juried shows in 2021:
TRA Medical Imaging public art display May-July, 2021

'Museum Contempo Fusion VI Installation" show held May 1-June 27, 2021

'Diversia: Culture Exhibition" May 1-31, 2021

"Fusion Art 6th Annual International Artist's Choice Art Exhibition," April-May 2021

Olympia, WA public "Spring Arts Walk," April 2021

Feather Fantasy:
Feather Fantasy accepted into the ISEA (International Society of Experimental Artists) "Utterly Unfathomable and Powerfully Profound" 2020 Members Only Online Juried Exhibition, November 15, 2020

Published Poetry

Published Poetry, Eleanor A. Hubbard

Contrasts:
Bice, Arlene A. (Ed) (2020) *What it is to be a Woman: An Anthology.* Independently published

Not Today, Satan & Stumbling into Groundlessness:
Soul-Lit: a journal of spiritual poetry, Volume 26, Winter 2021

Made in the USA
Middletown, DE
19 October 2021

50559714R00053